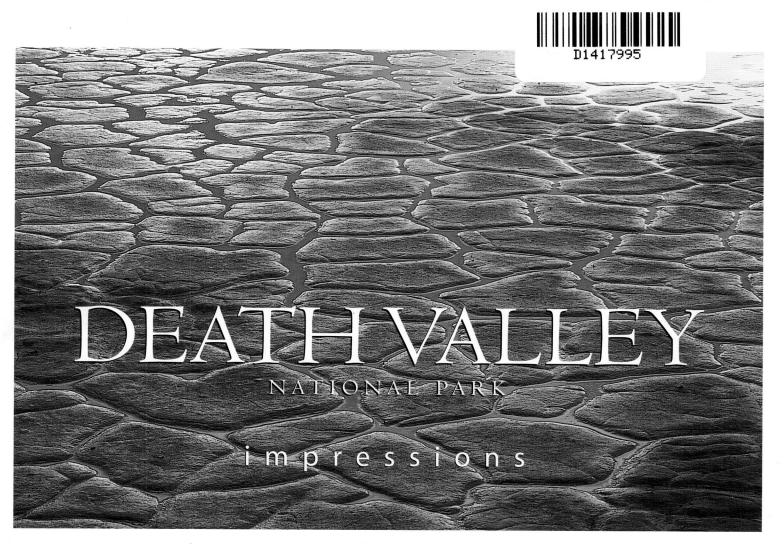

DEATH VALLEY

NATIONAL PARK

impressions

photography and text by Eric Wunrow

FARCOUNTRY
PRESS

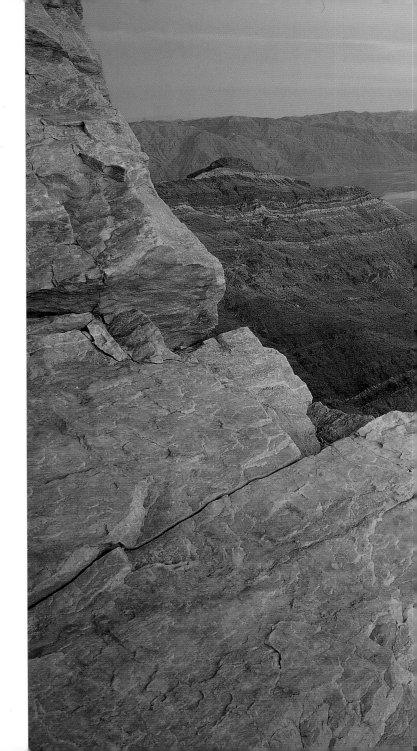

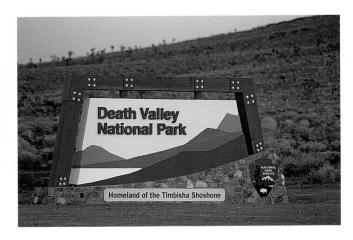

Above: A welcome sign for desert travelers.
Oben: Ein Willkommensschild für Besucher der Wüste.

Right: Wintry view from 6,433-foot Aguereberry Point.
Rechts: Winterliche Aussicht vom 1.962 Meter hohen Aguereberry Point.

Front cover: Mesquite Flat Dunes and Grapevine Mountains.
Titelseite: Dünen der Mesquite Flat und die Grapevine Mountains.

Back cover: Desert sunflowers below Telescope Peak.
Rückseite: Sonnenblumen, Geraea canescens, mit Telescope Peak im Hintergrund.

ISBN 10: 1-56037-295-8
ISBN 13: 978-1-56037-295-0

© 2004 Farcountry Press
Photography and text © 2004 Eric Wunrow

For more information on our books, write Farcountry Press, P.O. Box 5630, Helena, MT 59604; call (800) 821-3874; or visit www.farcountrypress.com.

Created, produced, and designed in the United States.
Printed in China.

15 14 13 12 11 10 2 3 4 5 6

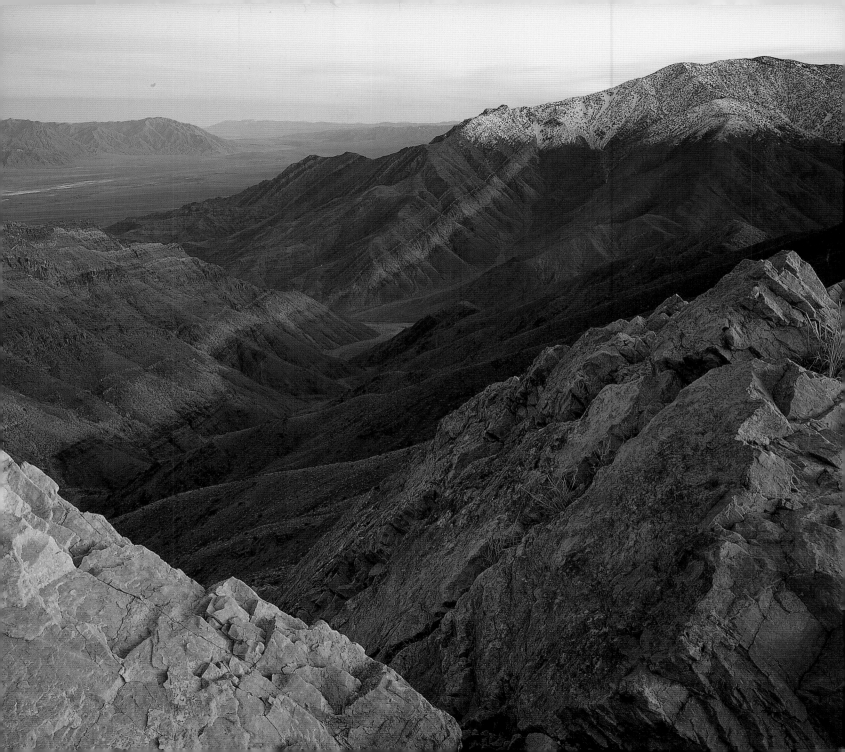

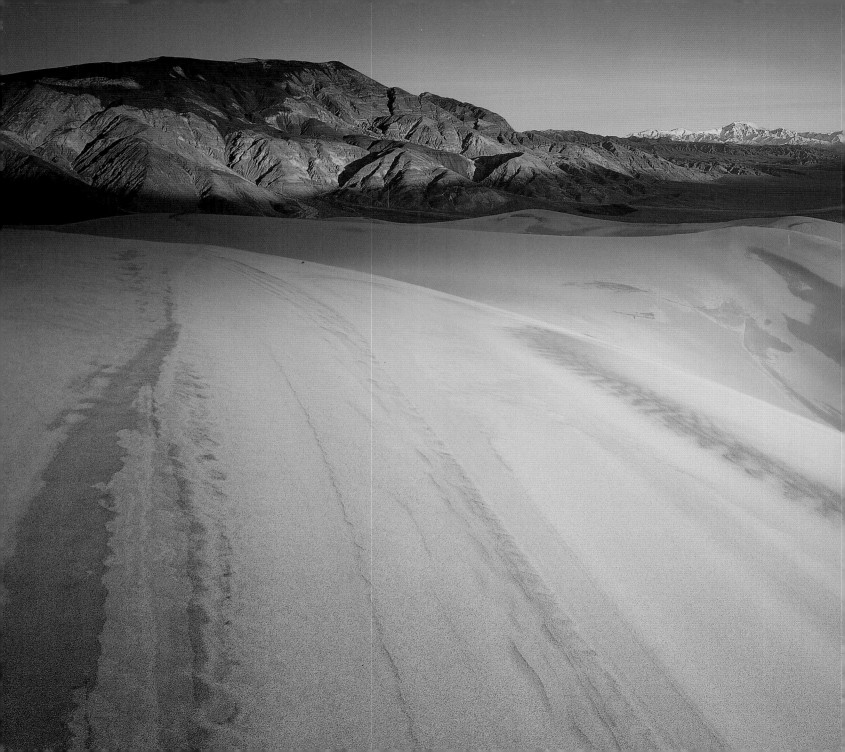

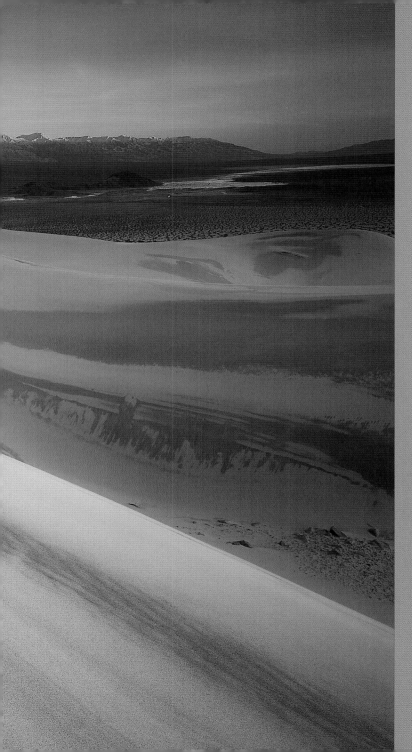

INTRODUCTION

by Eric Wunrow

Death Valley was simply in our way. As we were driving to our first Sierra Nevada climbing expedition in 1986, my wife Sandra woke me with "Hey, we're in Death Valley."

With no regard then for lands so low, I focused my thoughts on the high Sierra Nevadas 90 miles beyond. Our car was filled to the roof with equipment, and Hells Gate felt like a blow dryer. We related to the legendary Bennett and Arcane families, '49ers who cheated death by narrowly escaping the Valley during the California Gold Rush and gave this barren expanse its well-deserved moniker. And we pondered the Native American tribes that managed to maintain life in this area for millennia, leaving signs of their existence pecked into the stone.

After hauling 160 pounds of gear up the snowfields of 14,497-foot Mt. Whitney—the highest peak in the lower forty-eight states—the view from the summit confirmed that the snowmelt was late; the surrounding peaks we'd planned to climb were still too icy and dangerous. So, we descended and headed back to explore the depths of Death Valley—we'd stood on the continental United States' highest and lowest points within the span of thirty hours. Stunned by the arid heat after contending with Mt.

Panamint Dunes in shade, snowy Telescope Peak above.
Die Panamint Dünen im Schatten, darüber der schneebedeckte Telescope Peak.

Whitney's deep, slushy snow, we came to realize that the Sierra Nevadas, in effect, have starved Death Valley—and created a unique paradise.

This is a glorious place rich in contrasts. Telescope Peak soars 11,331 feet above Badwater Basin, the lowest point in the Western Hemisphere, at 282 feet below sea level. We once climbed Telescope Peak in a snowstorm at −5° F—marveling at how hardy bristlecone pines have tolerated 3,000 winters—while Badwater was clear and 80° F.

In Death Valley, the extraordinary is customary. Cliffs expose a billion years; massive canyons grind into the mountains, callously incising Earth's soul. Badlands colored by nature's ingenuity form Artists Palette—fantasy for the artist and geologist alike—where inspiration by one equals insight by the other.

This magical place is home to many unusual natural events. Winds move rocks the size of suitcases across Racetrack Valley, but no one yet has witnessed the phenomenon. Atmospheric changes at dawn and dusk create an otherwordly light that glows in three remarkable waves. At certain times of day, and at the right angle, spring flowers seem to appear, as a mirage, then vanish in the heat. Reality becomes interpretive.

By far the most unusual event we've experienced in the Valley occurred when a mile-wide "tidal wave" suddenly appeared, flowing across Death Valley and slowing to a stop like surf on a beach. If that wasn't shocking enough, it was covered with an inch of foamy algae that started to dissipate as the wave lost momentum—but not before it soiled my photo packs in a place where I was sure they'd stay dry. Green slime lost its mythic status and was alive in Death Valley. Would I believe it myself if not for my photographs? (see photo on page 8–9).

We sheepishly reported the "incident" at Furnace Creek. After questioning our sanity, a ranger referred us to the park geologist, who theorized that algae had bloomed under the Valley's salt crust and expanded to the breaking point. That year, record rains had re-filled the Pleistocene-era Lake Manly playa, where mineral salts collect, dry, and expand into plates with 1-inch-high ridges. Surging out of a fault in the salt crust, the algae flowed like water from an ice crack.

The Valley we once considered a barrier to the snowy reaches of the Sierras became an inspiring and beloved destination. Many untold mysteries remain in Death Valley, a strange land rich in cultural and natural history—truly an international treasure.

A spring rainbow ignites a Joshua tree forest.
Ein Frühlingsregenbogen setzt einen Joshua Tree Kaktus ins rechte Licht.

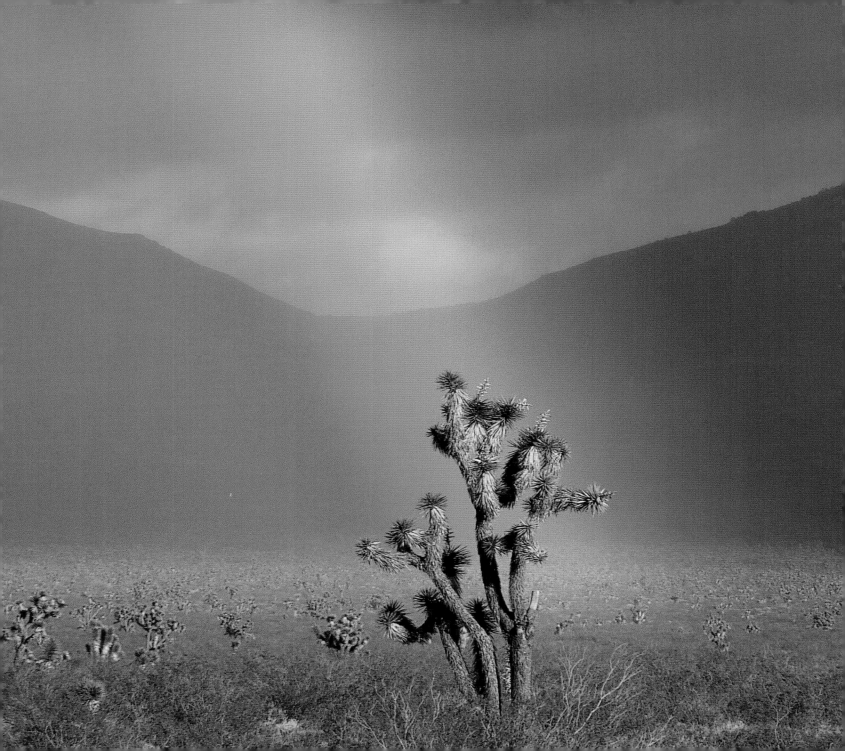

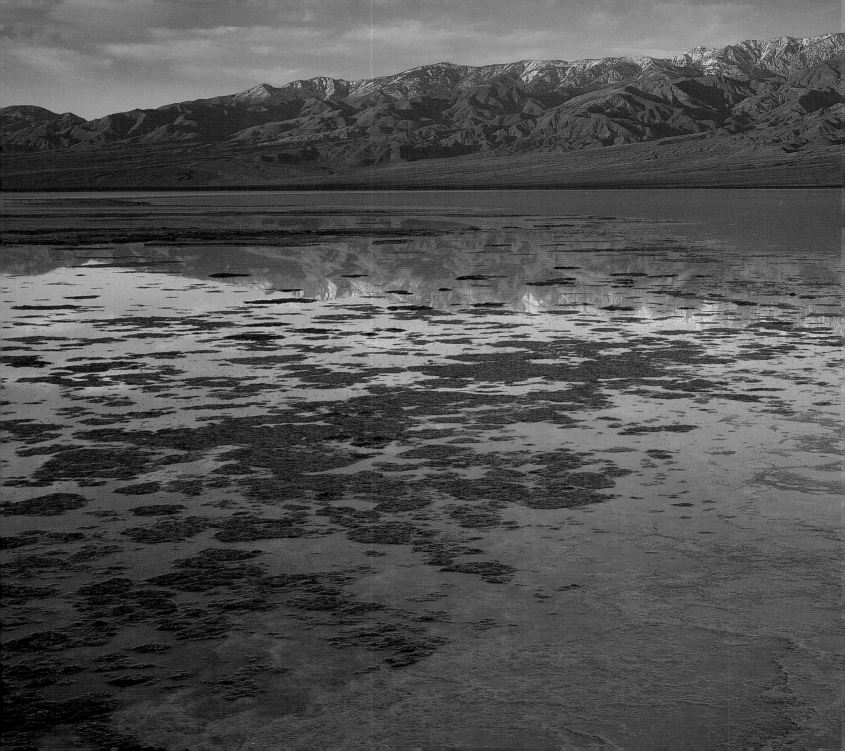

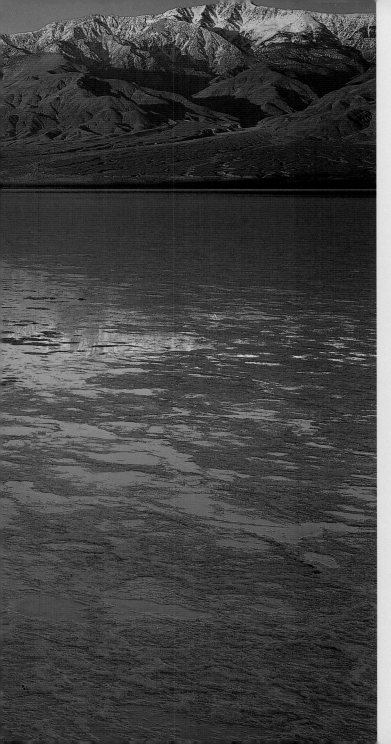

EINFÜHRUNG

Von Eric Wunrow

D as Death Valley lag einfach auf unserem Weg. Als wir 1986 zu unserer ersten Kletterexpedition in die Sierra Nevada fuhren, weckte mich meine Frau Sandra mit "Hey, wir sind im Death Valley".

Damals noch ohne Achtung für so niedrige Landstriche, konzentrierten sich meine Gedanken auf die hohen Sierras in 90 Meilen Entfernung. Unser Auto war bis zum Dach mit Ausrüstung gefüllt und Hells Gate fühlte sich an wie ein Trockengebläse. Wir konnten uns in die legendären Bennett und Arcane Familien hineinversetzen, welche dem Tod von der Schippe gesprungen und während des 1849er Goldrauschs in Kalifornien gerade noch dem Tal entkommen waren. Sie gaben dieser unfruchtbaren Weite seinen wohlverdienten Namen. Wir sinnierten auch über die Indianerstämme, die hier über hunderte von Jahren gelebt und Zeichen Ihrer Existenz in Stein gemeißelt haben.

Nachdem wir 73 Kilo Ausrüstung die Schneefelder des 4.422 Meter hohen Mt. Whitney—dem höchsten Punkt innerhalb der 48 zusammenhängenden Vereinigten Staaten—hinaufgetragen hatten, bestätigte ein Blick vom Gipfel, dass die Schneeschmelze sich verspätet hatte; die umliegenden Spitzen der Berge, die wir besteigen wollten, waren noch zu vereist und gefährlich. Also stiegen wir ab und fuhren zurück, um die Tiefen des Death Valley zu erkunden. In einem

Rarely photographed algal bloom.
Die selten fotografierte Algenblüte.

Zeitraum von 30 Stunden standen wir auf dem höchsten und dem niedrigsten Punkt innerhalb der kontinentalen USA.

Gelähmt von der trockenen Hitze, nachdem wir gerade noch mit Mt. Whitneys tiefen, nassen Schnee gekämpft hatten, erkannten wir, dass die Sierra Nevadas Death Valley ausgetrocknet und damit gleichzeitig ein einzigartiges Paradies auf dem Grunde Nordamerikas geschaffen haben.

Death Valley ist ein herrlicher Ort, reich in Kontrasten. Der Telescope Peak türmt sich 3.456 Meter über Badwater Basin, dem mit 86 Meter unter Meereshöhe niedrigsten Punkt der westlichen Hemisphäre. Einmal haben wir den Telescope Peak in einem Schneesturm bei −20.5°C bestiegen, fasziniert davon, wie die Borstenkiefern 3.000 Winter überstanden haben, während es gleichzeitig in Badwater klar war und dort das Thermometer 27°C zeigte.

Im Death Valley ist das Außergewöhnliche normal. Klippen legen eine Milliarde Jahre offen; breite Schluchten graben sich in die Berge, schneiden in die Seele der Erde. Vom Genius der Natur gefärbte Ödländer formen Artists Palette—phantastisch sowohl für den Künstler als auch für den Geologen—wo des Einen Inspiration des Anderen Einsicht ist.

Dieses magische Land ist Heimat für viele ungewöhnliche Naturereignisse. Der Wind bewegt Felsen groß wie Reisekoffer über das Racetrack Valley, aber niemand hat dieses Phänomen bisher beobachtet. Atmosphärische Veränderungen bei Sonnenauf- und -untergang schaffen ein außerirdisches Licht, welches in drei Wellen erglüht. Zu bestimmten Zeiten des Tages, im richtigen Winkel, scheint es,

als würden Frühlingsblumen als Fata Morgana erscheinen und dann in der Hitze verschwinden. Realität wird zur Interpretation.

Das bei weitem ungewöhnlichste Ereignis, dass wir erlebt haben, ereignete sich, als eine "Flutwelle," eine Meile breit, plötzlich auftauchte, durchs Tal floss und wie eine Welle am Strand langsamer wurde und schließlich zum Stillstand kam. Als ob nicht schockierend genug, war die Welle mit 2,5 cm schaumiger Algen bedeckt, die sich verteilten als die Welle an Fahrt verlor, allerdings nicht bevor sie meine Fototaschen, die ich sicher im Trockenen wähnte, verdreckten. Der grüne Schleim verlor sein mystisches Dasein und wurde im Death Valley lebendig. Würde ich es selber glauben, gäbe es nicht die Fotos? (Siehe Foto auf den Seiten 8-9).

Verlegen berichteten wir den "Vorfall" in Furnace Creek. Nachdem er unseren Verstand angezweifelt hatte, verwies uns ein Ranger an einen Park-Geologen, welcher vermutete, dass die Algen unter der Salzkruste des Tales geblüht und bis zum Überlaufen expandiert hatten. In dem Jahr hatte Rekordregenfall den Lake Manly, der im Pleistozän geformt wurde, wieder gefüllt. Dort sammeln sich Mineralsalze, trocknen und expandieren zu Platten mit 2,5 cm hohen Rändern. Aus einem Riss in dieser Salzkruste ergossen sich die Algen wie Wasser aus einer Gletscherspalte.

Das Tal, welches wir einst als Hindernis auf dem Weg zu den schneebedeckten Höhen der Sierras betrachteten, wurde ein inspirierender und geliebter Ort. Viele ungelüftete Geheimnisse bleiben im Death Valley, einem seltsamen Land reich an Geschichte und ein echter internationaler Schatz.

Petroglyphs endure as bold inscriptions of Native American life.
Felszeichnungen überdauern als Zeichen indianischen Lebens.

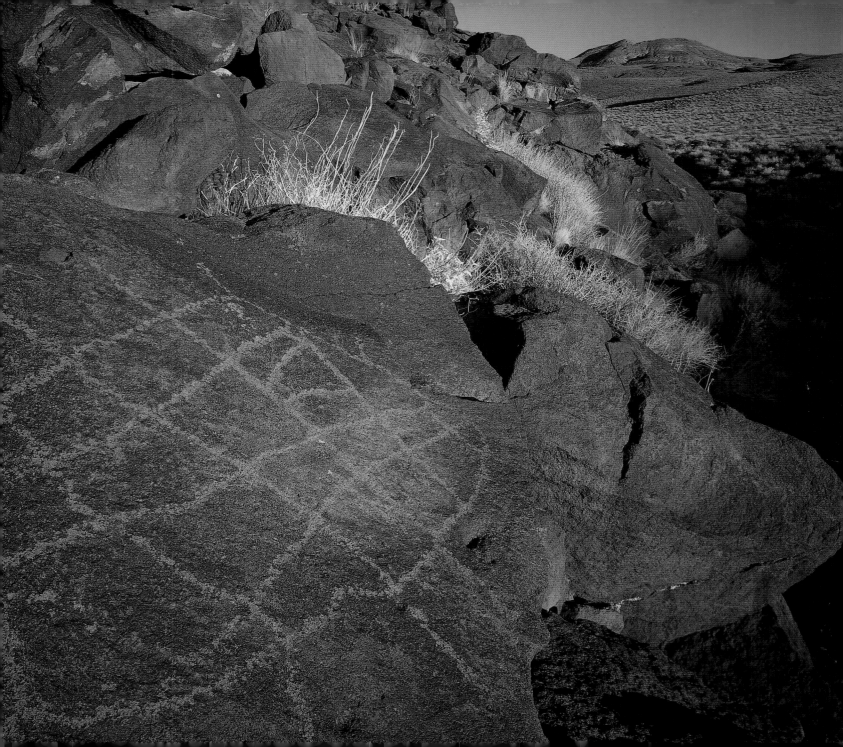

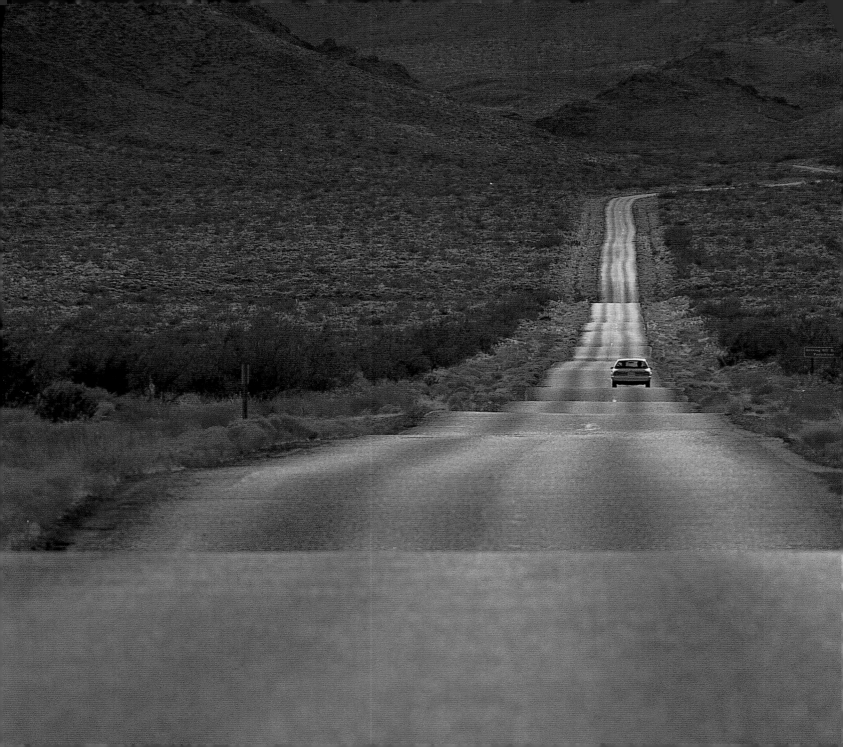

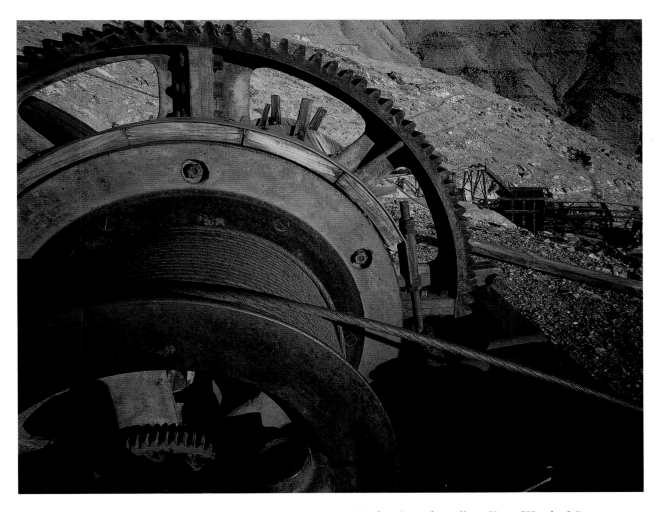

Above: Buckets of gold ore tethered to this aerial tram plunged 1,500 feet down for milling, Keane Wonder Mine.
Oben: Keane Wonder Mine: An diese Seilbahn gehängte, mit Gold beladene Eimer, wurden zur Weiterverarbeitung 458 Meter in die Tiefe befördert.

Facing page: Nevada Highway 374 courses over waves of alluvial debris on its westward route to Daylight Pass.
Gegenüber: Der Nevada Highway 374 verläuft über Wellen angeschwemmten Gerölls.

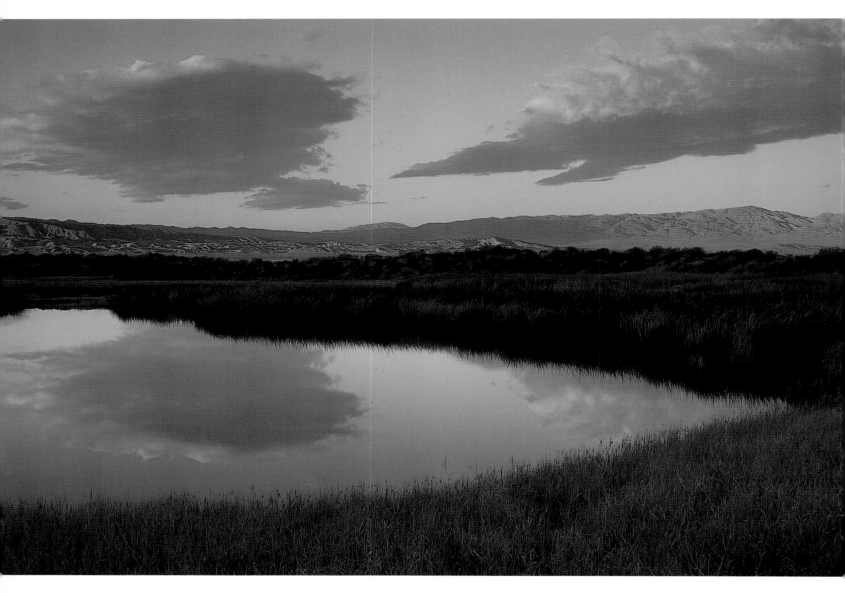

An oasis for desert wildlife, Saratoga Spring appears as an unlikely feature in this harsh desert.
Saratoga Springs, eine Oase für Tiere der Wüste, erscheint in dieser rauen Landschaft irreal.

Right: Roadrunner, Furnace Creek.
Rechts: Ein Roadrunner (Furnace Creek).

Below: Venerable and wily, the coyote is a
common sight throughout the Park.
Unten: Ein Kojote, häufig zu sehen im Park.

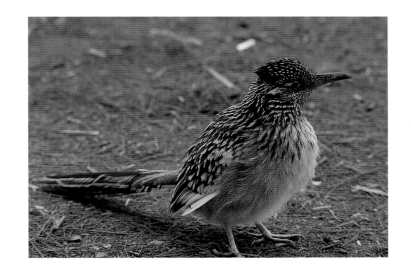

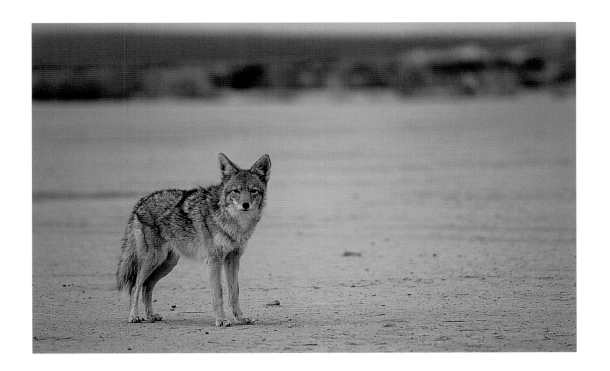

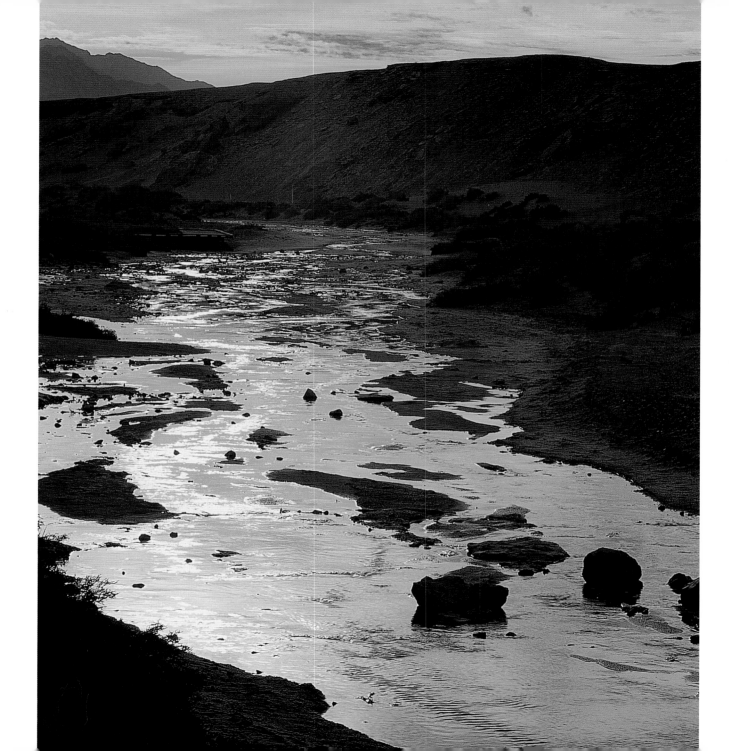

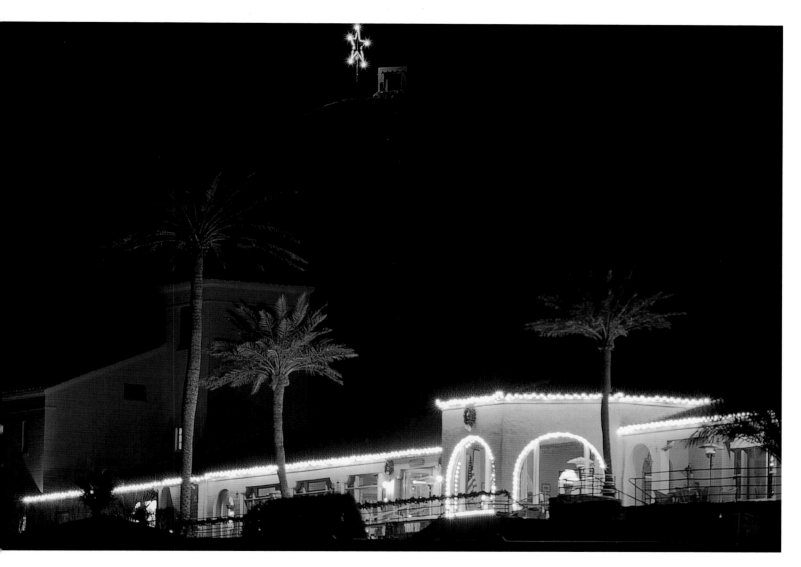

Above: Furnace Creek Inn shines in Christmas regalia.
Oben: Furnace Creek Inn leuchtet im weihnachtlichen Ornat.

Facing page: Flowing above ground and below, Salt Creek runs from below Mesquite Flat to Cottonball Basin.
Gegenüber: Salt Creek fließt von unterhalb Mesquite Flat bis Cottonball Basin ober- und unterirdisch.

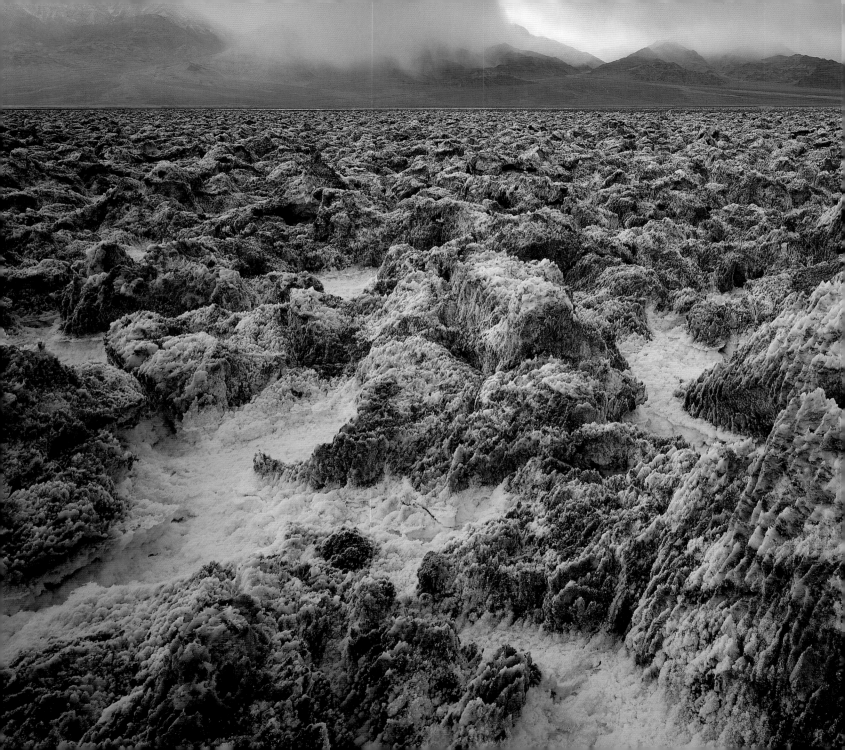

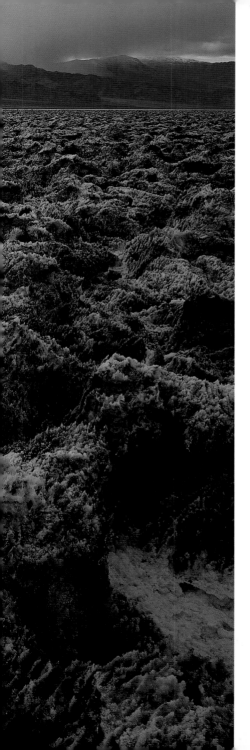

Above: In the 1880s, twenty mule-team wagons loaded with borax braved 165 miles of scorching heat on the rough trail to Mojave depot, Harmony Borax Works.
Oben: In den 1880ern trotzten Gespanne, beladen mit Borax und gezogen von zwanzig Maultieren, der sengenden Hitze auf dem rauen, über 265 Kilometer langen Weg zur Endstation in Mojave (Harmony Borax Works).

Left: At Devils Golf Course, minerals and sediments left over from Ice Age lakes and carried by rare floods are deposited on the valley floor; when the water evaporates, these formations emerge.
Links: Auf dem Devils Golf Course wurden Mineralien und Sedimente aus der Eiszeit abgelagert, die von den seltenen Fluten herangetragen wurden; wenn das Wasser verdunstet entstehen diese Formationen.

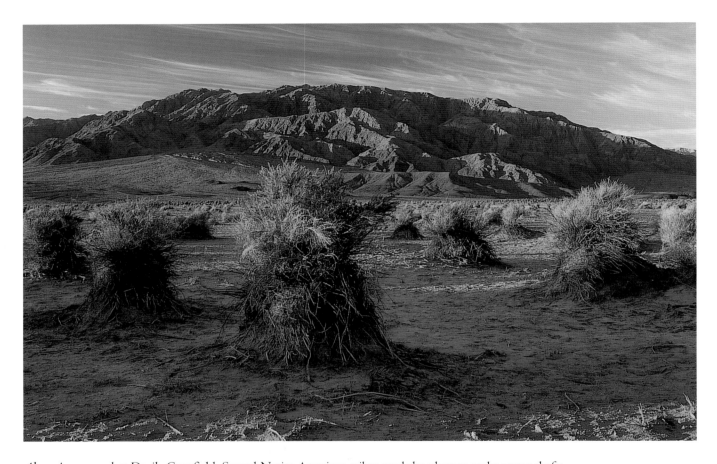

Above: Arrowweed at Devils Cornfield. Several Native American tribes used the plant to make arrow shafts.
Oben: Arrowweed, ein Mitglied der Sonnenblumenfamilie, im Devils Cornfield. Einige Indianerstämme nutzten die Pflanze zur Herstellung von Pfeilen.

Facing page: Dantes View offers an expansive vista of Death Valley from over a mile above.
Gegenüber: Dantes View bietet aus einer Höhe von über 1,6 Kilometern einen weiten Blick auf das Death Valley.

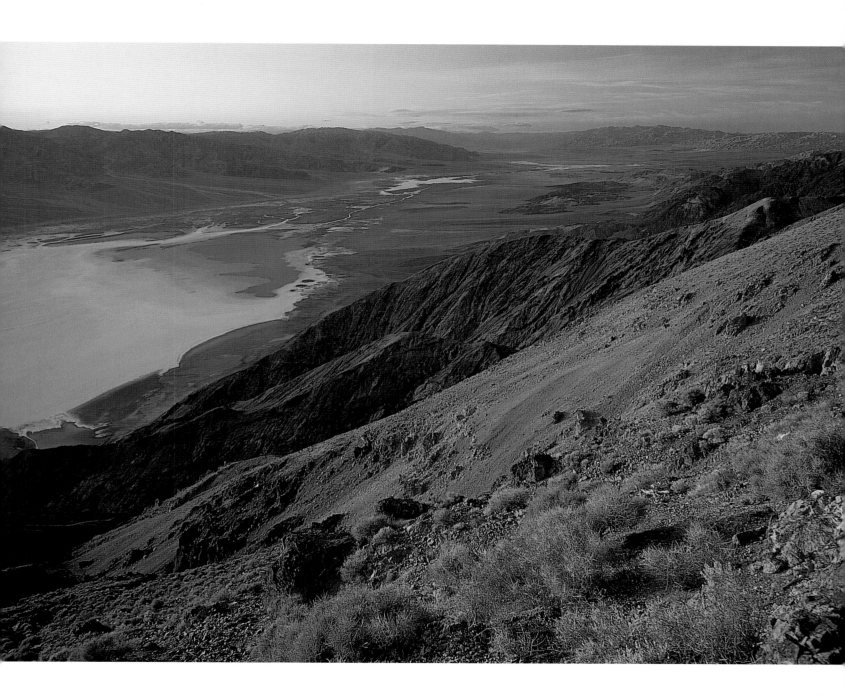

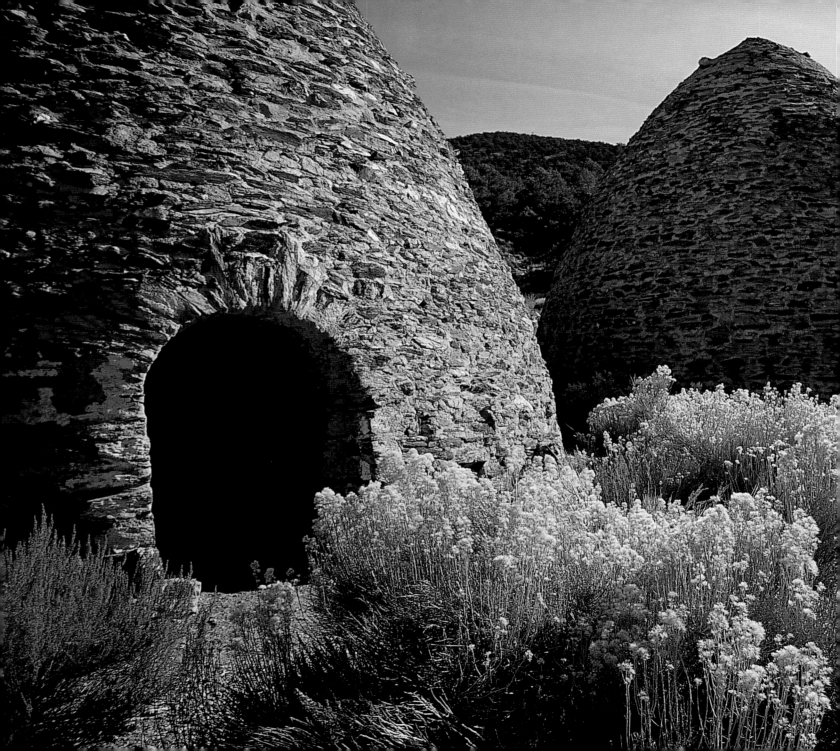

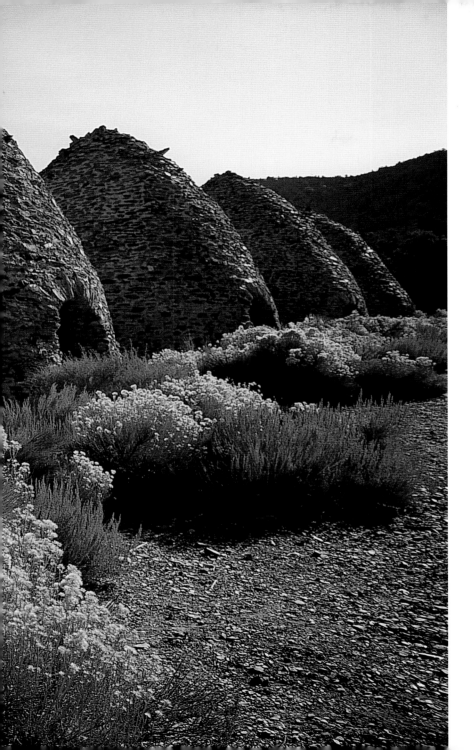

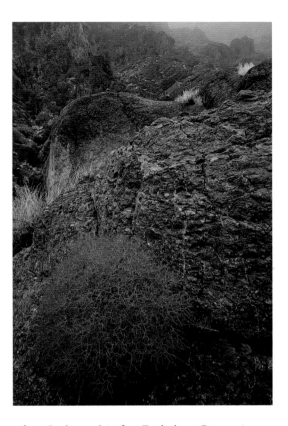

Above: Snakeweed in fog, Dedeckera Canyon.
Oben: Schlangenkraut im Nebel (Dedeckera Canyon).

Left: The ten kilns at Wildrose fired timbers into charcoal for mine smelters in the Argus Range.
Links: Die zehn Öfen in Wildrose dienten zur Holzkohleherstellung für die Hüttenwerke in der Argus Range.

Right: Privately owned Cerro Gordo, Inyo Mountains.
Rechts: Das in Privatbesitz befindliche Cerro Gordo in den Inyo Mountains.

Facing page: Salt plates along West Side Road are formed by cycles of flooding and drying.
Gegenüber: Die Salzplatten entlang der West Side Road werden durch Zyklen von Flut und Trockenheit geformt.

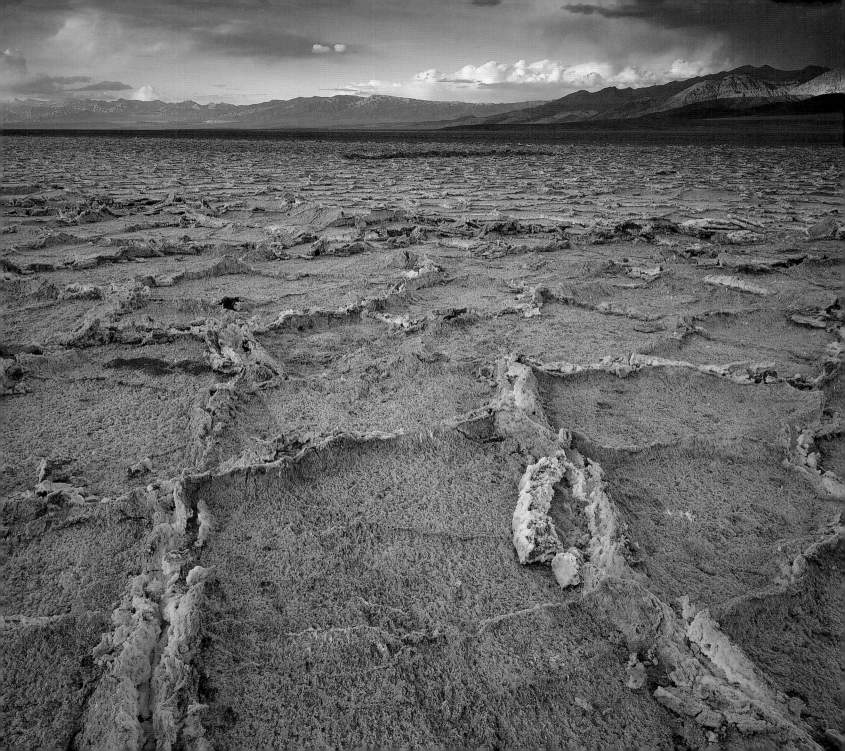

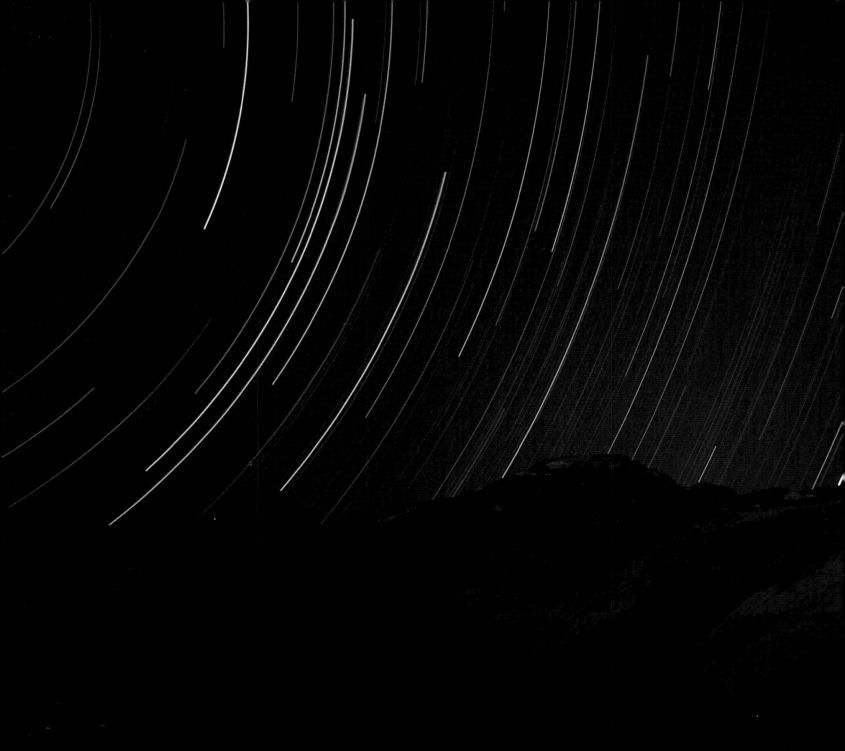

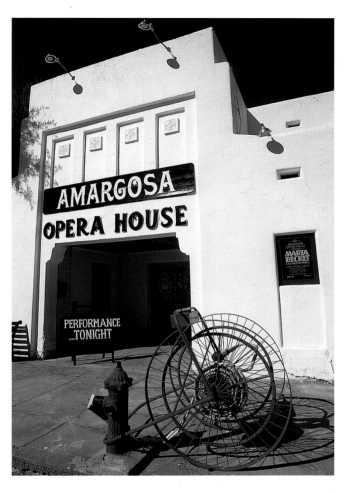

Above: The Amargosa Opera House in Death Valley Junction.
Oben: Das Amargosa Opernhaus in Death Valley Junction.

Left: Night exposure of the Black Mountains, Artists Drive.
Links: Langzeitbelichtung der Black Mountains (Artists Drive).

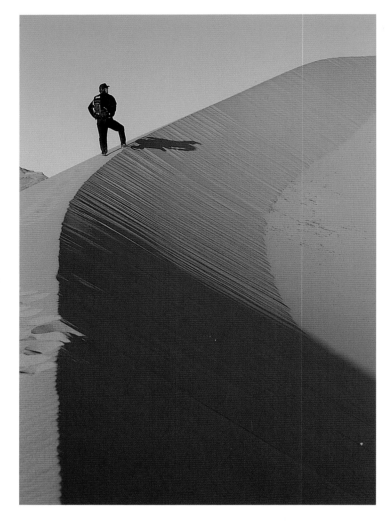

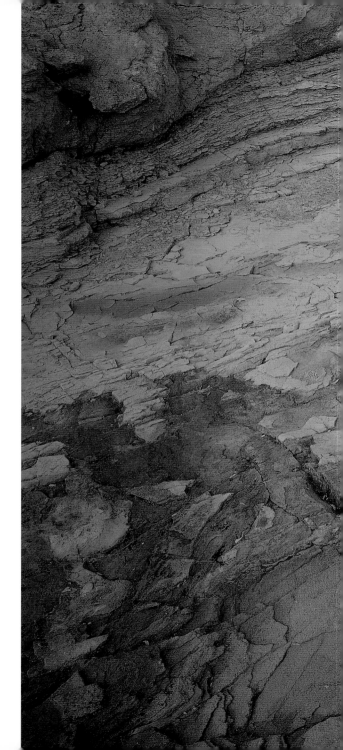

Above: A desert wanderer enjoys a dune ascent at Mesquite Flat.
Oben: Ein Wüstenwanderer genießt die Besteigung einer Düne in Mesquite Flat.

Right: Yellow mudstone in Golden Canyon, near Furnace Creek.
Rechts: Gelbes Schlammgestein im Golden Canyon in der Nähe von Furnace Creek.

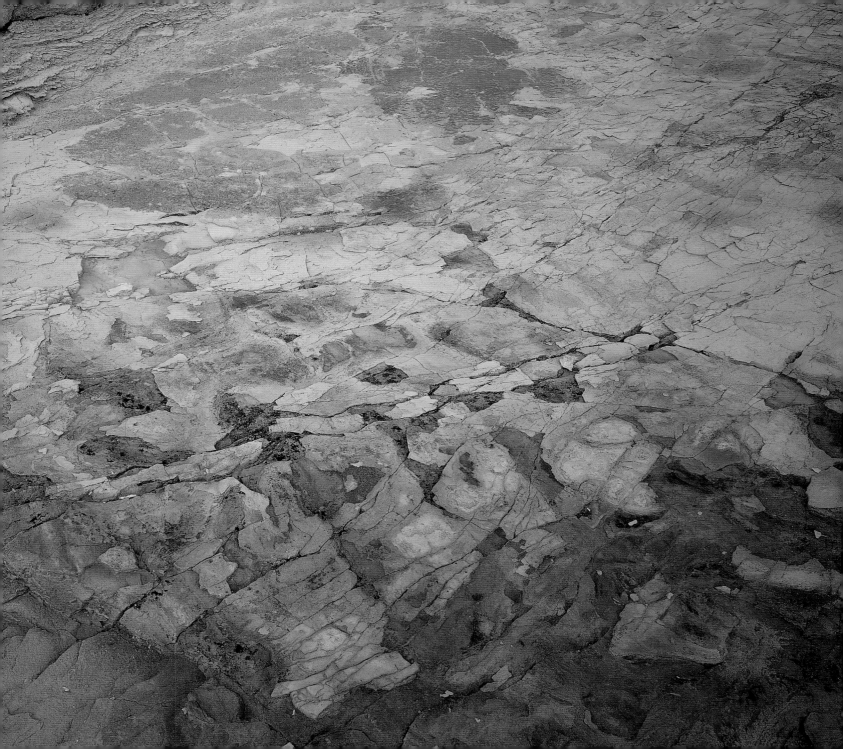

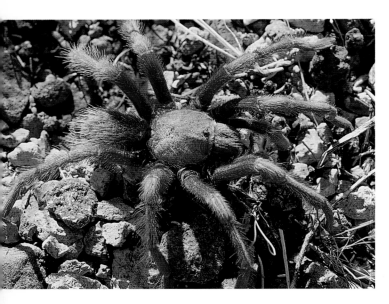

Above: Desert tarantulas, this one photographed during its autumn migration, thrive throughout the Mojave Desert.
Oben: Taranteln, hier auf der Herbstwanderung, gedeihen in der Mojave Wüste.

Right: Descendant of the burros left behind by miners.
Rechts: Ein Abkömmling der Packesel, die die Bergarbeiter hinterlassen haben.

Facing page: The Ashford brothers quietly spent decades trying to turn gold into profit, then left their Ashford Mill behind.
Gegenüber: Die Gebrüder Ashford versuchten Jahrzehnte lang, aus Gold Geld zu machen, bevor sie ihr Hüttenwerk verließen.

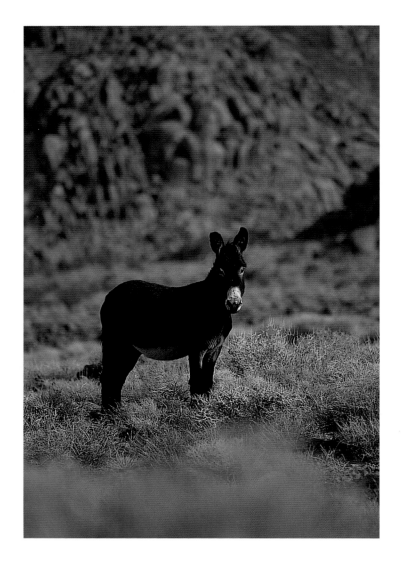

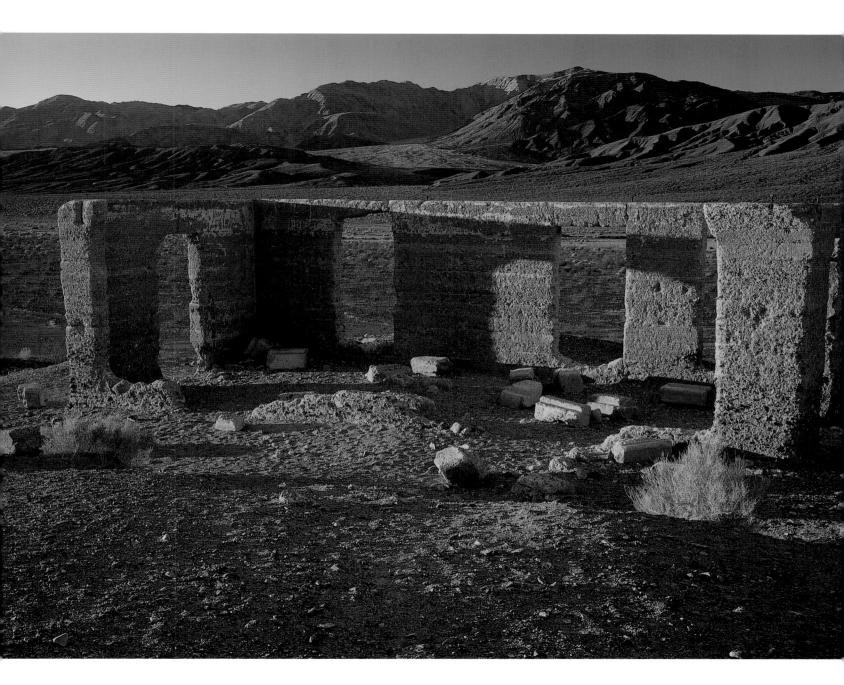

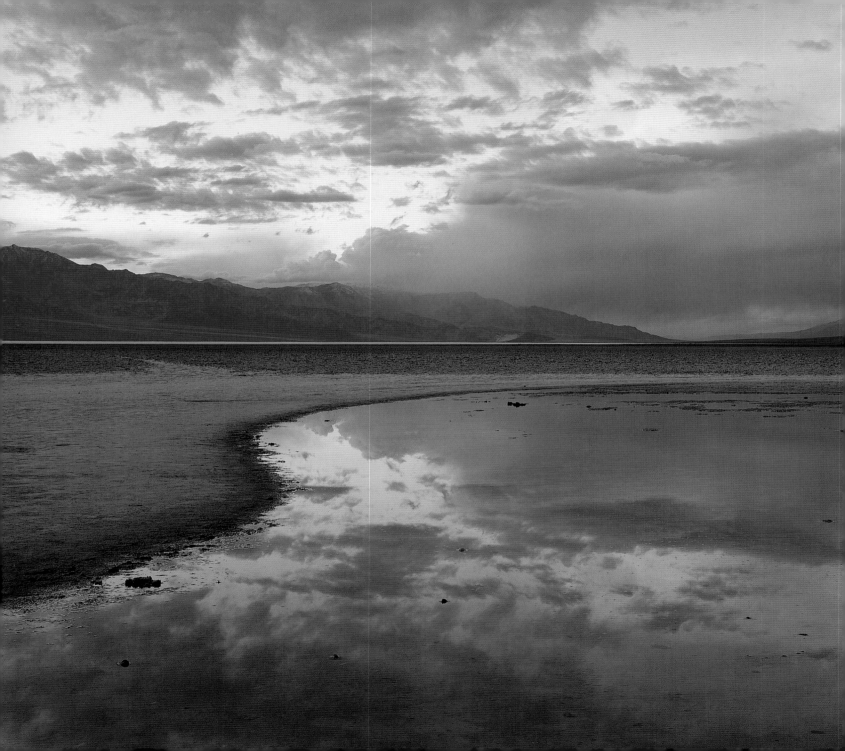

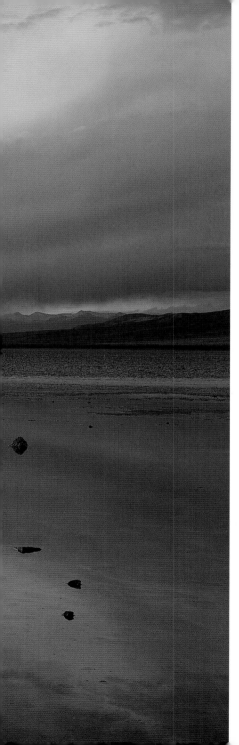

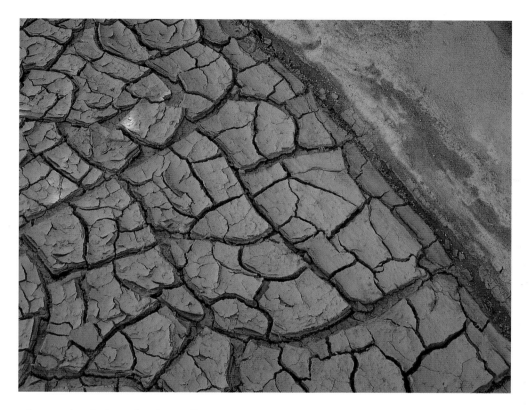

Above: Light silt from flood runoff cracks as it dries, Furnace Creek Wash.
Oben: Schlick aus Flutwassern reißt während des Trocknens ein (Furnace Creek Wash).

Left: At 279.8 feet below sea level, the spring-fed Badwater pool collects its water from the Black Mountains, as well as the expansive Lower Carbonate Aquifer.
Links: 85,3 Meter unter Meereshöhe sammelt dieser quellengespeiste Badwater-Teich sein Wasser aus den Black Mountains und dem weitläufigen Lower Carbonate Aquifer.

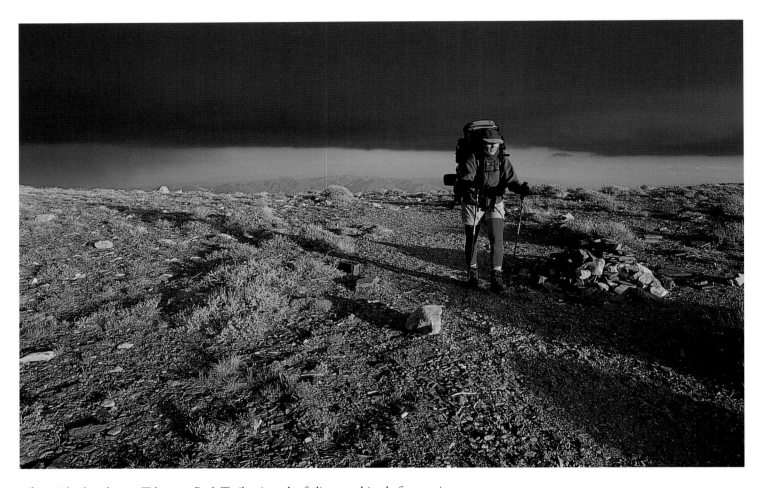

Above: A backpacker on Telescope Peak Trail enjoys the fading sunshine before a winter storm.
Oben: Ein Bergwanderer auf dem Telescope Peak Trail erfreut sich an den letzten Sonnenstrahlen vor dem Sturm.

Facing page: Darwin Falls flows year round, creating an intimate oasis near Panamint Springs.
Gegenüber: Darwin Falls fließt ganzjährig und gestaltet eine intime Oase in der Nähe von Panamint Springs.

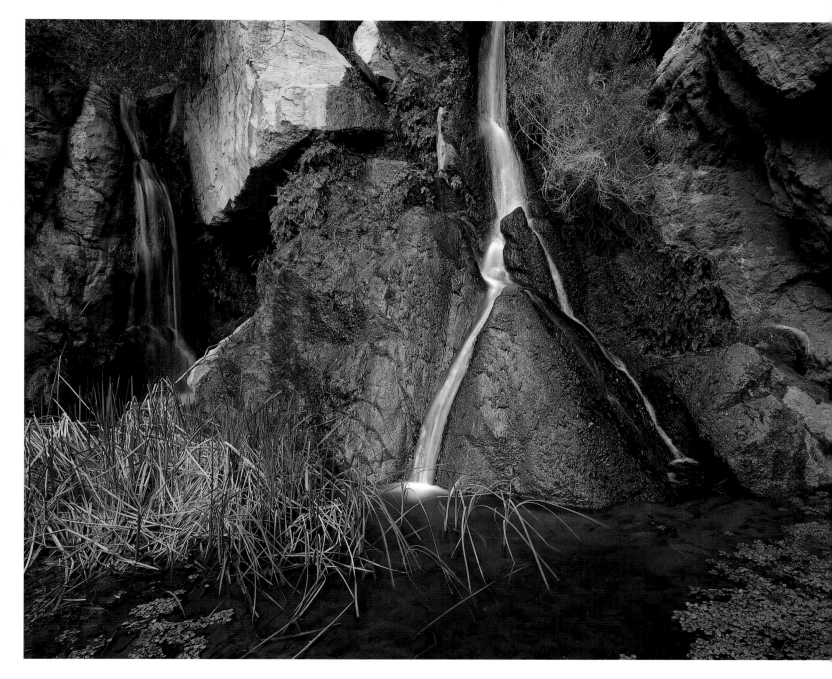

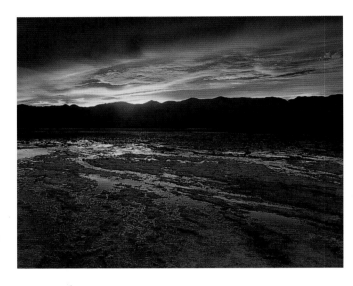

Above: Fiery sunset and salt pool, near Mormon Point.
Oben: Feuriger Sonnenuntergang, reflektiert in einem Salzwasserteich in der Nähe von Mormon Point.

Right: Rising more than 650 feet, the remote dunes in Eureka Valley are the highest in California.
Rechts: Die abgelegenen, 198 Meter hohen Dünen des Eureka Valley sind die höchsten in Kalifornien.

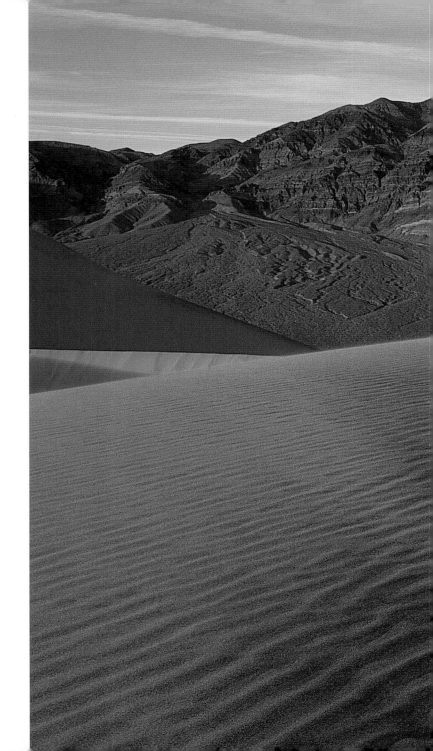

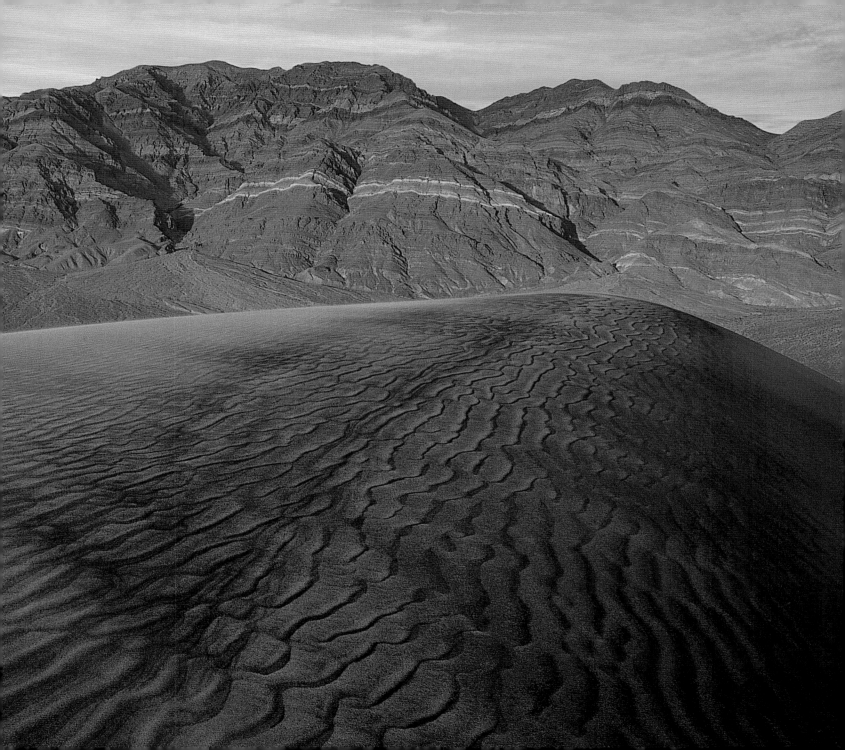

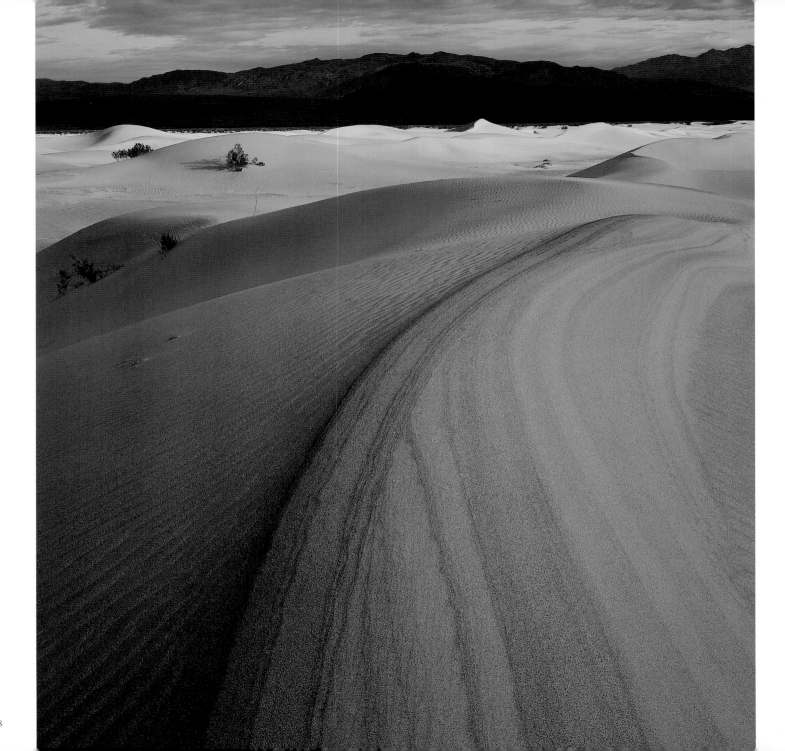

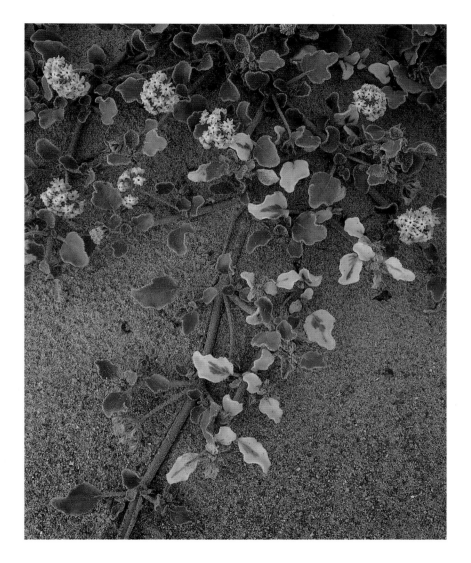

Left: Sand verbena in bloom, Ibex Dunes.
Links: Blühende Sand Verbena, Abronia villosa (Ibex Dünen).

Facing page: Losing strength at the foot of the Inyo Mountains, wind sculpts sand, forming the Saline Valley Dunes.
Gegenüber: Weil er am Fuße der Inyo Mountains an Stärke verliert, formt der Wind den Sand und lässt die Saline Valley Dünen entstehen.

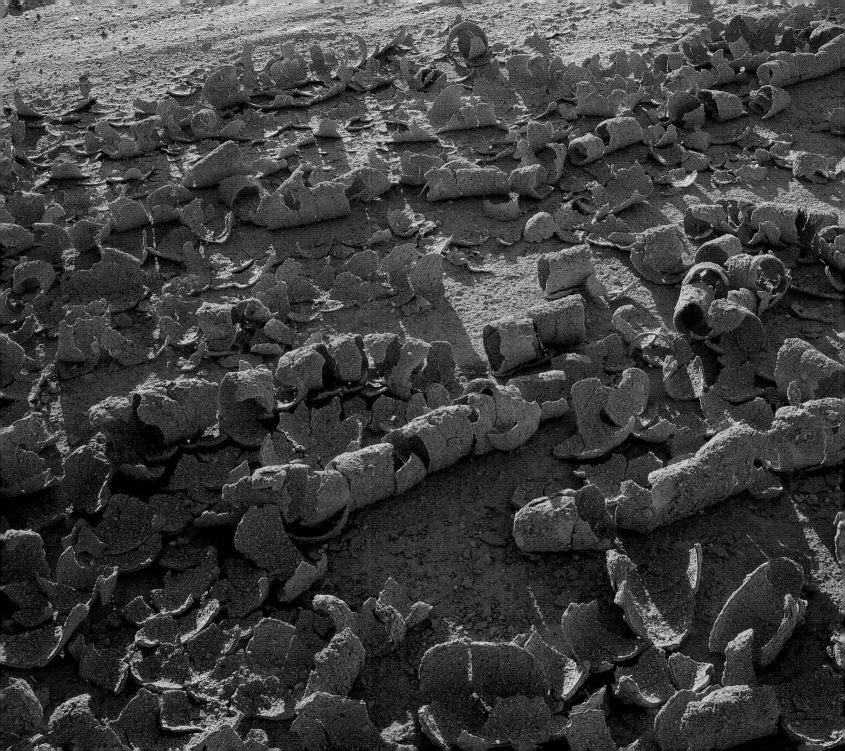

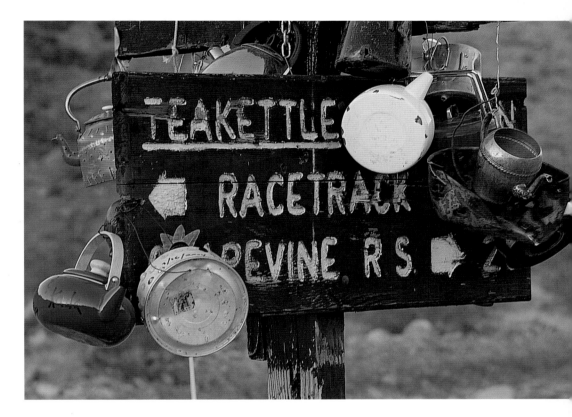

Above: In the upper reaches of Racetrack Valley, the sign at Teakettle Junction points the way.
Oben: Am oberen Rand des Racetrack Valley zeigt das Schild an der Teakettle Junction den Weg.

Left: Amargosa River mud dries and curls, becoming art in the Park's southern recesses.
Links: Schlamm des Amargosa River, ausgetrocknet und zusammengerollt, wird zur Kunst in den südlichen Winkeln des Parks.

Following pages: As softer silt wears away, harder clays are exposed, Death Valley Wash.
Folgende Seiten: Wenn weicherer Schlick abgetragen wird, kommt härterer Ton zum Vorschein (Death Valley Wash).

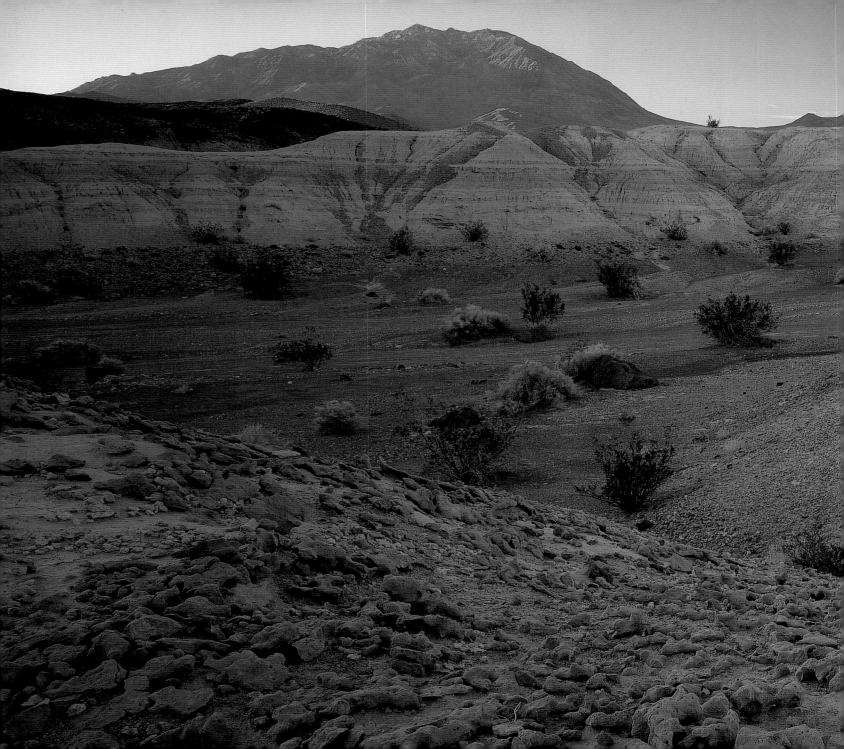

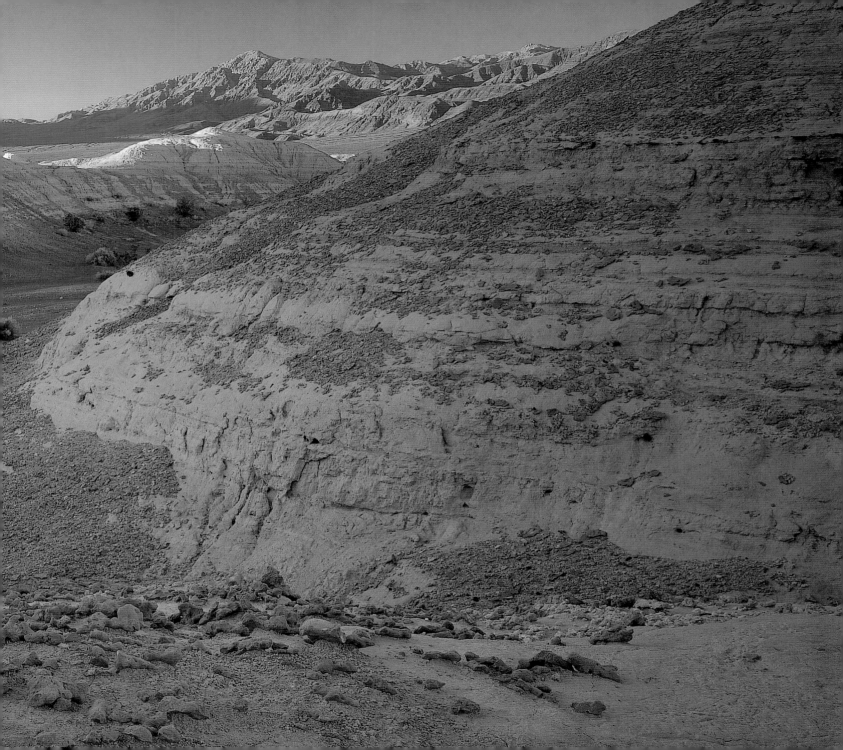

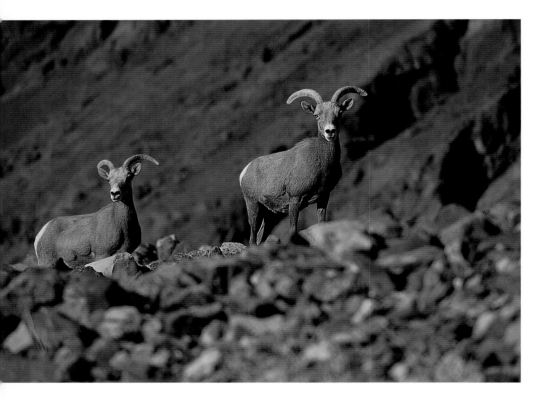

Above: An extremely rare sight near Death Valley's floor: desert bighorn sheep.
Oben: Ein sehr seltener Anblick am Talboden des Death Valley: amerikanische Dickhornschafe.

Right: Manly Beacon and the distant, snowy Panamint Range, Zabriskie Point.
Rechts: Manly Beacon und die ferne, schneebedeckte Panamint Range (Zabriskie Point).

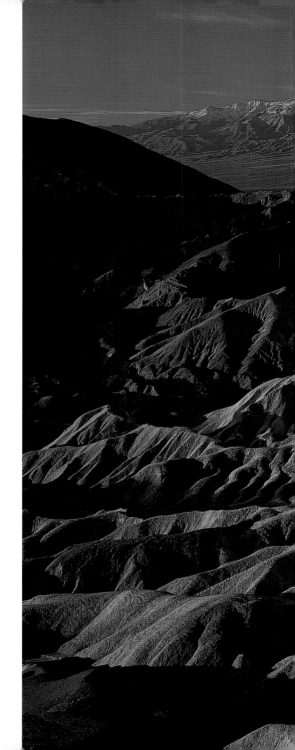

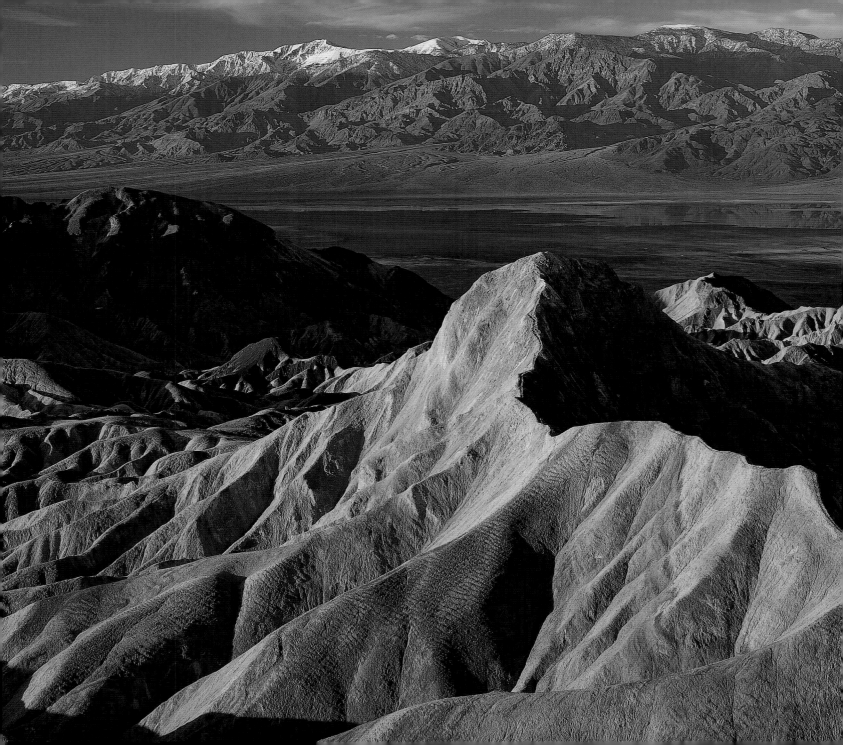

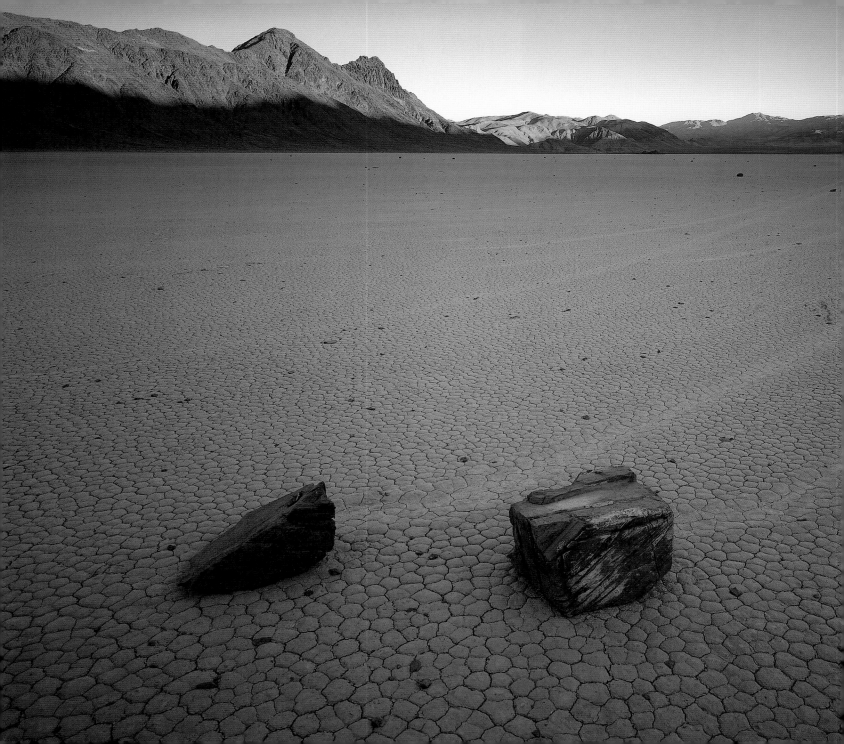

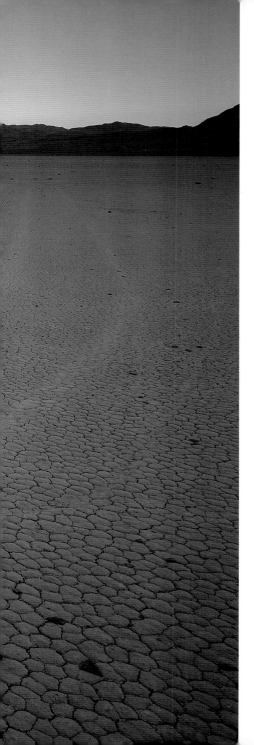

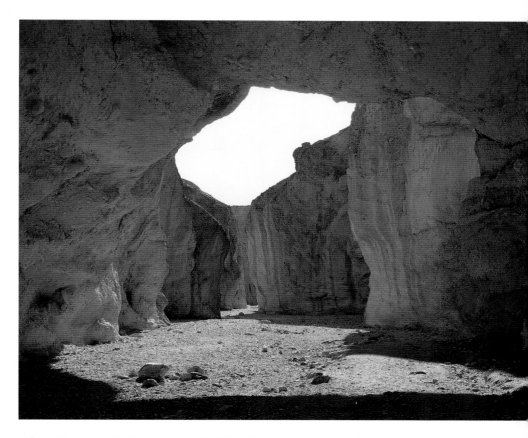

Above: The natural bridge in Natural Bridge Canyon was created when floodwaters undercut the old fanglomerate rocks, forcing a passage through.
Oben: Die natürliche Brücke im Natural Bridge Canyon wurde geformt, als Fluten die alten Fanglomeratgesteine erodierten und sich einen Weg bahnten.

Left: Theories of Racetrack Valley's moving rocks abound, but none have been proven definitively.
Links: Theorien über die sich bewegenden Steine im Racetrack Valley gibt es zuhauf, aber keine wurde bis jetzt bewiesen.

47

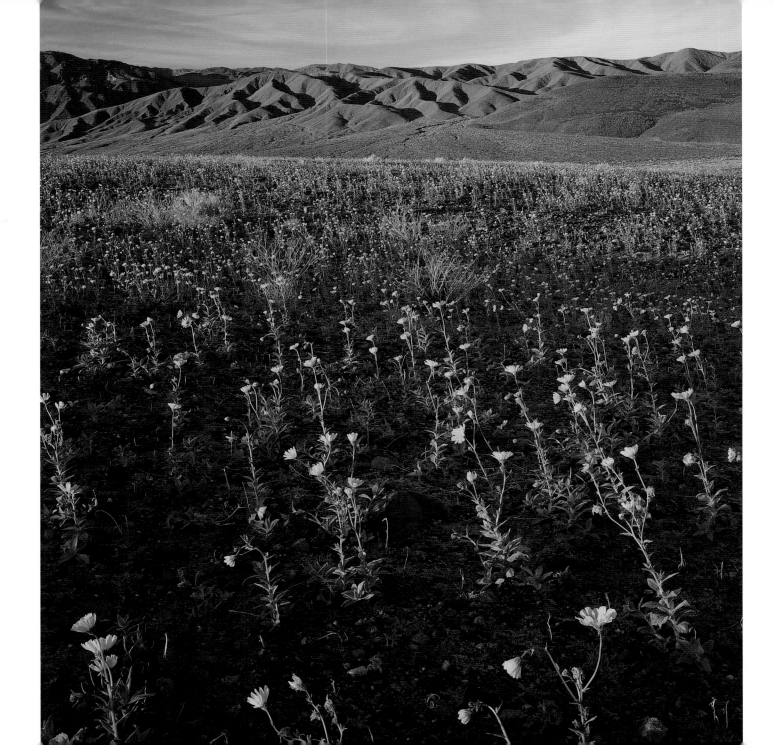

Right: Death Valley from Keane Wonder Mine Trail.
Rechts: Death Valley, gesehen vom Keane Wonder Mine Trail.

Below: Dune footprints redden under a fiery sky.
Unten: Fußabdrücke im Sand röten sich unter feurigem Himmel.

Facing page: Desert sunflowers and Confidence Hills.
Gegenüber: Sonnenblumen und die Confidence Hills.

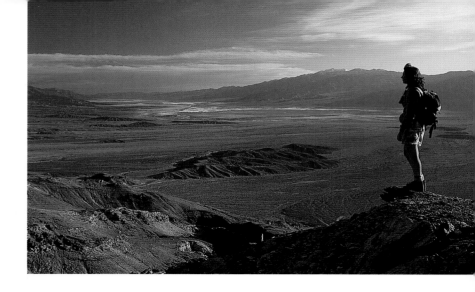

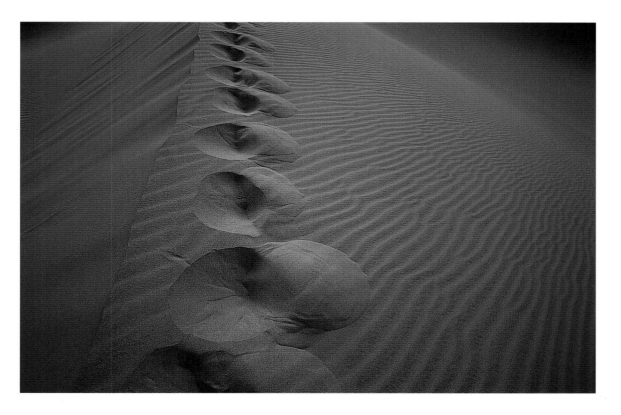

Badlands above Gower Gulch aglow
at twilight, Zabriskie Point.

Ödländer über der Gower Gulch
glühen in der Dämmerung
(Zabriskie Point).

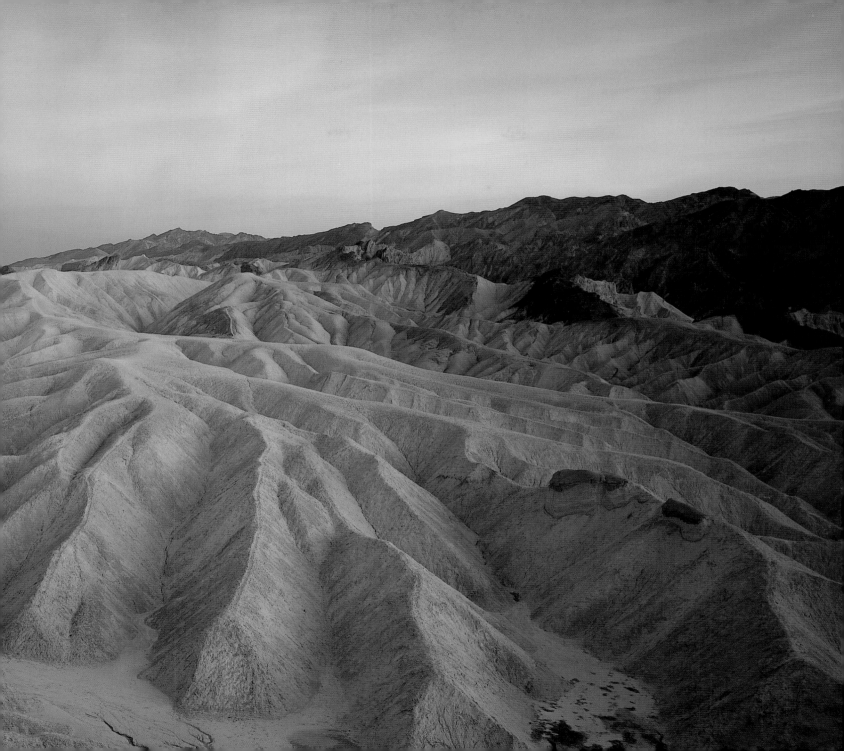

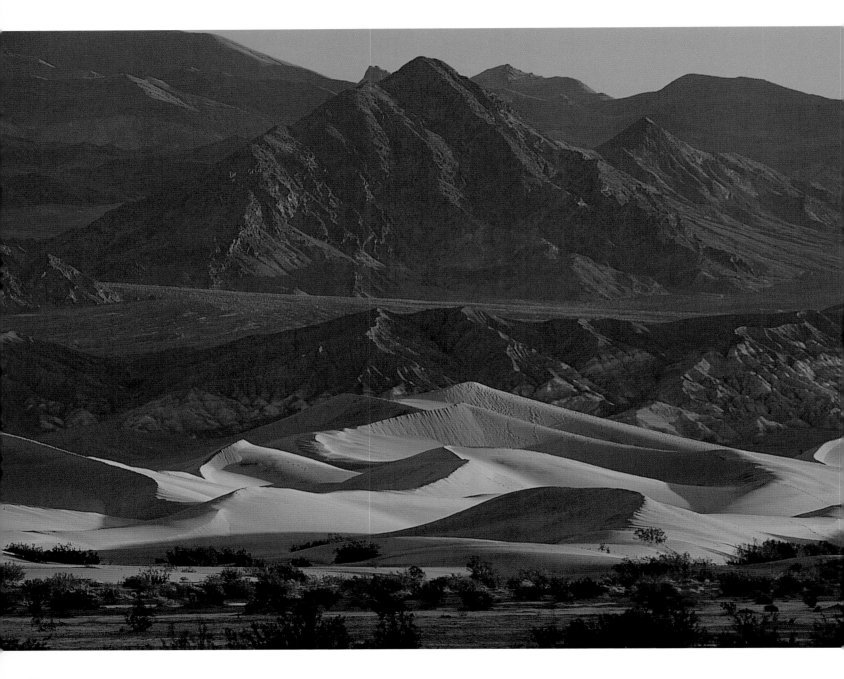

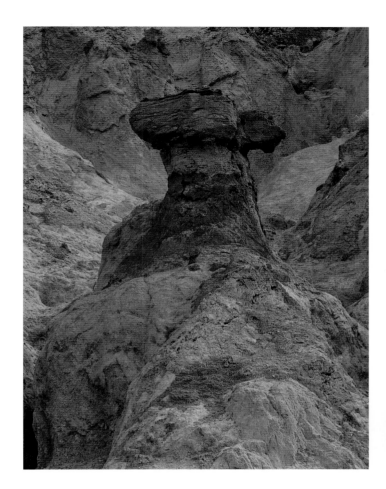

Left: Pedestal rock in the Black Mountains.
Links: Sockelförmiger Felsen in den Black Mountains.

Below: Scorpions are at home—but elusive—in the desert terrain.
Unten: Skorpione sind in der Wüste zu Hause, aber selten zu sehen.

Facing page: Death Valley Buttes and dunes of Mesquite Flat.
Gegenüber: Death Valley Buttes (kleine Tafelberge) und Dünen der Mesquite Flat.

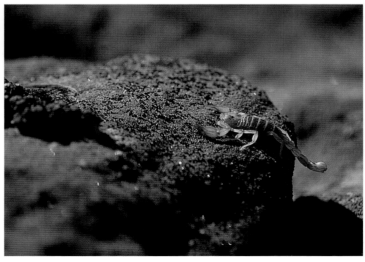

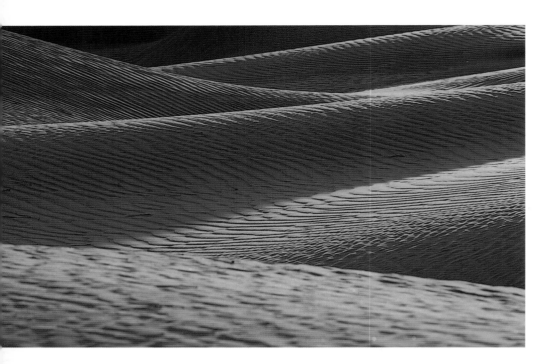

Above: Woven sand ridges.
Oben: Das Zusammenspiel von Wind und Sand hat auf den Dünen ein Gewebe aus Graten und Verwerfungen geformt.

Right: Desert grave of Val Nolan.
Rechts: Das Grab von Val Nolan.

Far right: Desert holly and Ubehebe Crater, formed by a massive steam explosion, Cottonwood Mountains.
Gegenüber: Stechpalme am Rande des von einer gewaltigen Dampf-explosion geformten Ubehebe Crater in den Cottonwood Mountains.

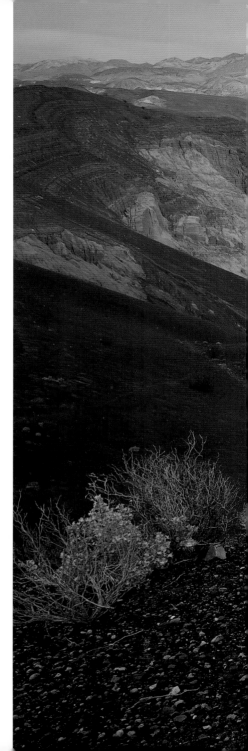

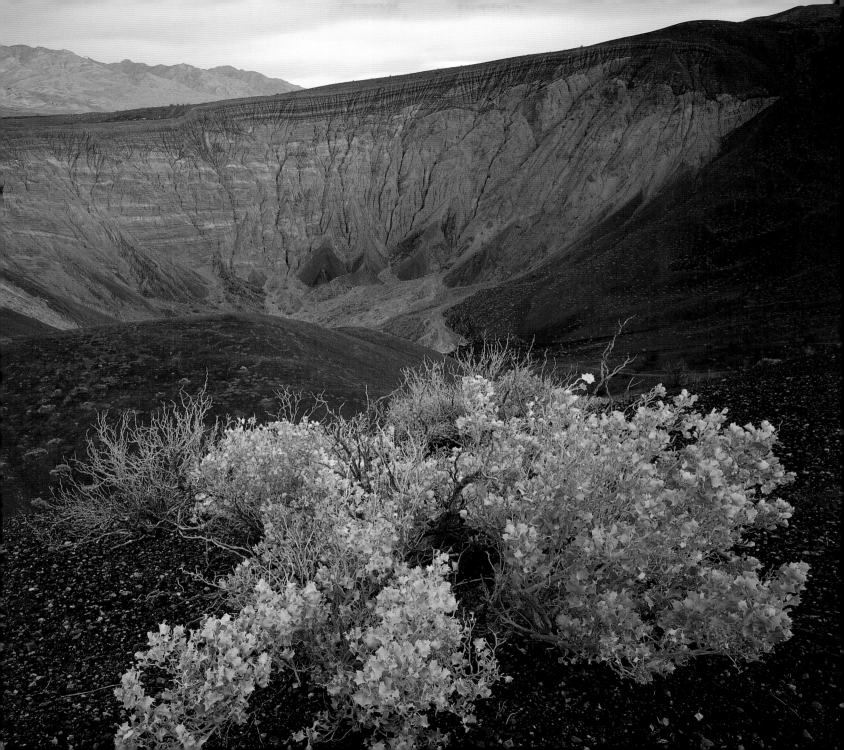

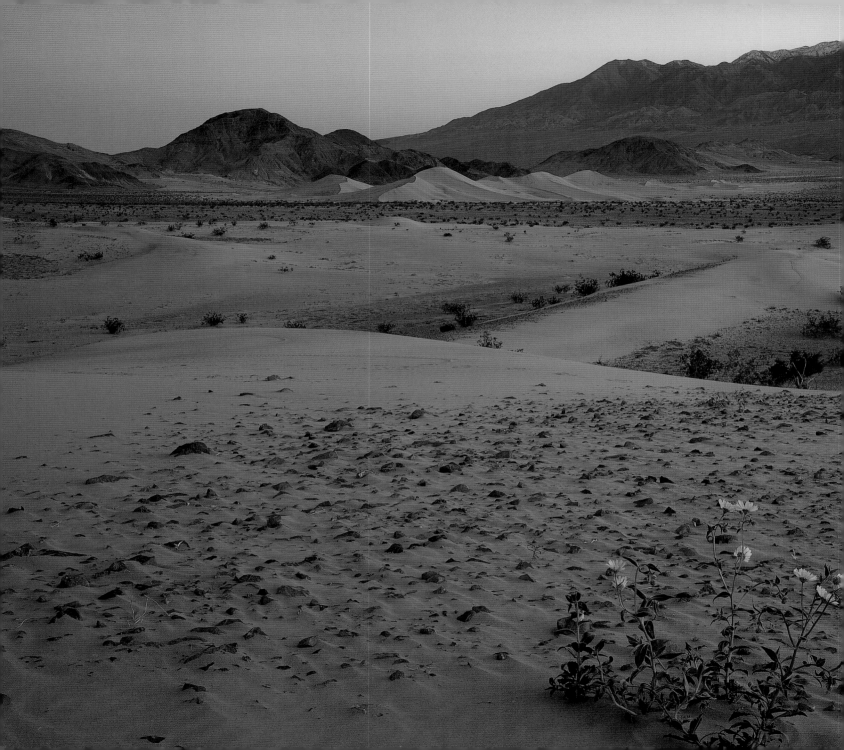

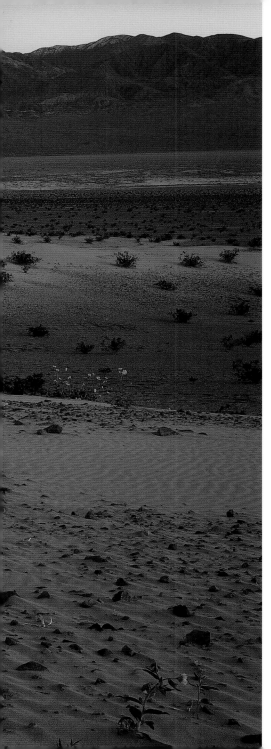

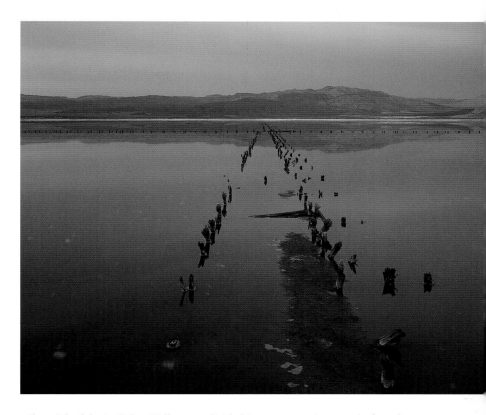

Above: The lake in Saline Valley was divided into evaporation ponds for salt mining in the early 1900s.
Oben: Der See im Saline Valley wurde Anfang der 1900er in mehrere Verdunstungsbecken zur Salzgewinnung geteilt.

Left: Desert sunflowers and the pinks of early twilight, Ibex Dunes.
Links: Sonnenblumen und das Rosa-rot der Dämmerung in den Ibex Dünen.

Right: The marble narrows of Mosaic Canyon display water's erosive power, Tucki Mountain.
Rechts: Die Marmorschluchten des Mosaic Canyon zeigen die erosive Kraft des Wassers (Tucki Mountain).

Below: One of the West's largest sulfur deposits was extracted near Crater, Last Chance Range.
Unten: Eines der größten Schwefelvorkommen im Westen wurde nahe Crater in der Last Chance Range abgebaut.

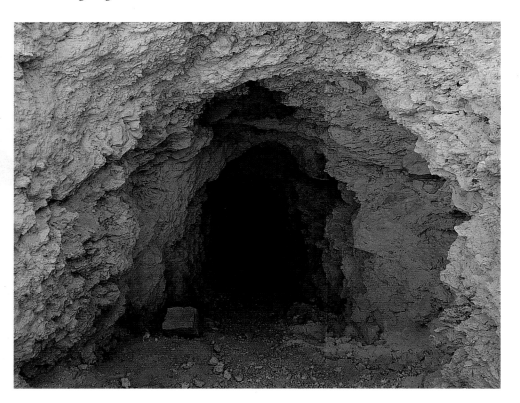

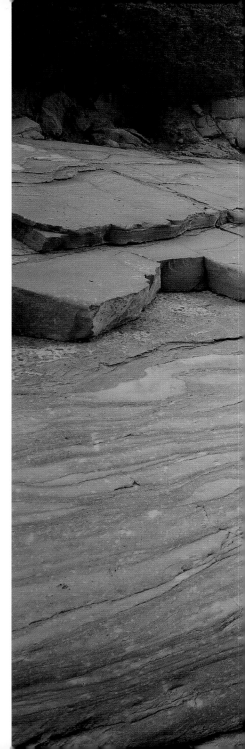

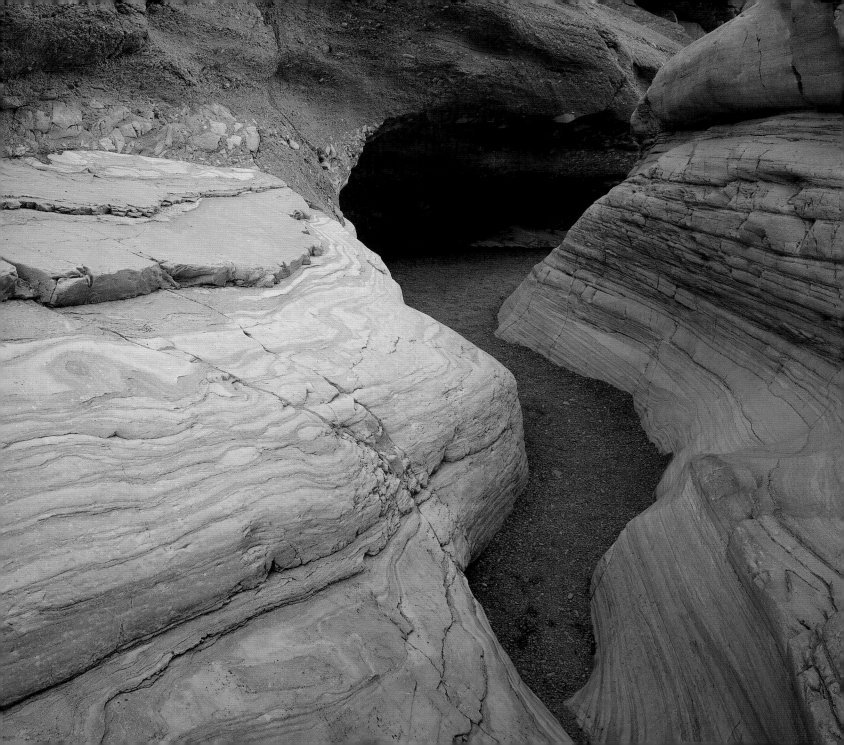

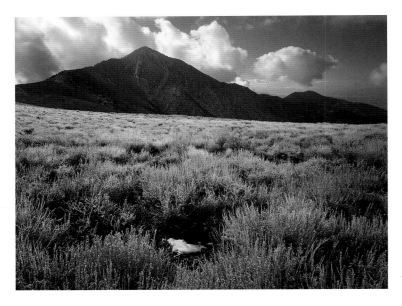

Above: A cold winter morning graces the 11,049-foot summit of Telescope Peak, highpoint of the park.
Oben: Der Gipfel des 3.370 Meter hohen Telescope Peak, der höchste Punkt im Park, an einem kalten Wintermorgen.

Right: A winter sunrise warms limber pines after a night of below-zero temperatures, near 9,980-foot summit of Bennett Peak.
Rechts: Der Sonnenaufgang nach einer Nacht mit tiefen Minustemperaturen wärmt endlich die Kiefern, Pinus flexilis, nahe der Spitze des 3.044 Meter hohen Bennett Peak.

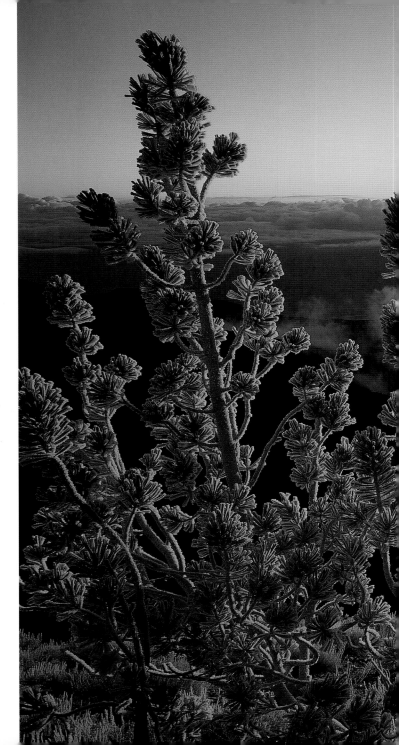

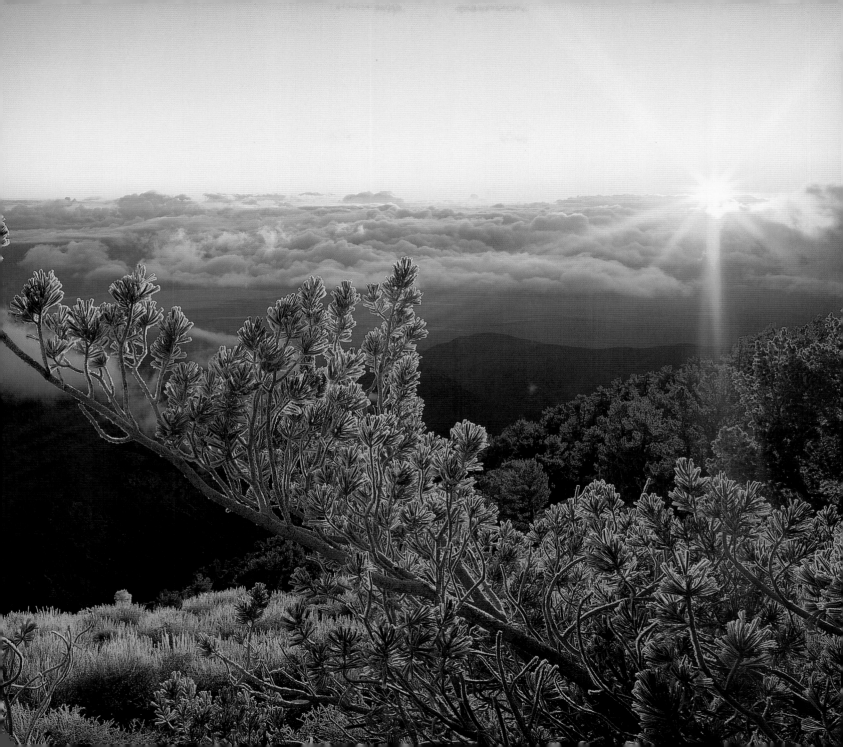

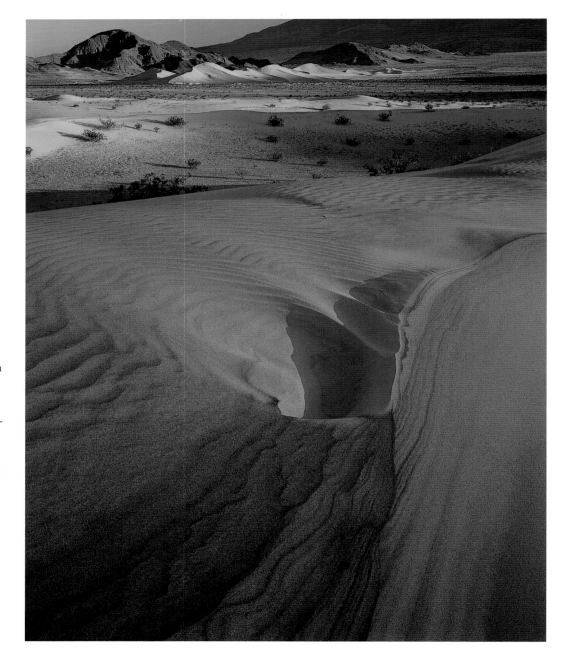

Right: The pristine Ibex Dunes are in the Park's southeastern corner.
Rechts: Die unberührten Ibex Dünen befinden sich in der süd-östlichen Ecke des Parkes.

Facing page: A hiker studies the narrow confines of Fall Canyon.
Gegenüber: Ein Wanderer schaut sich die Wände des Fall Canyon an.

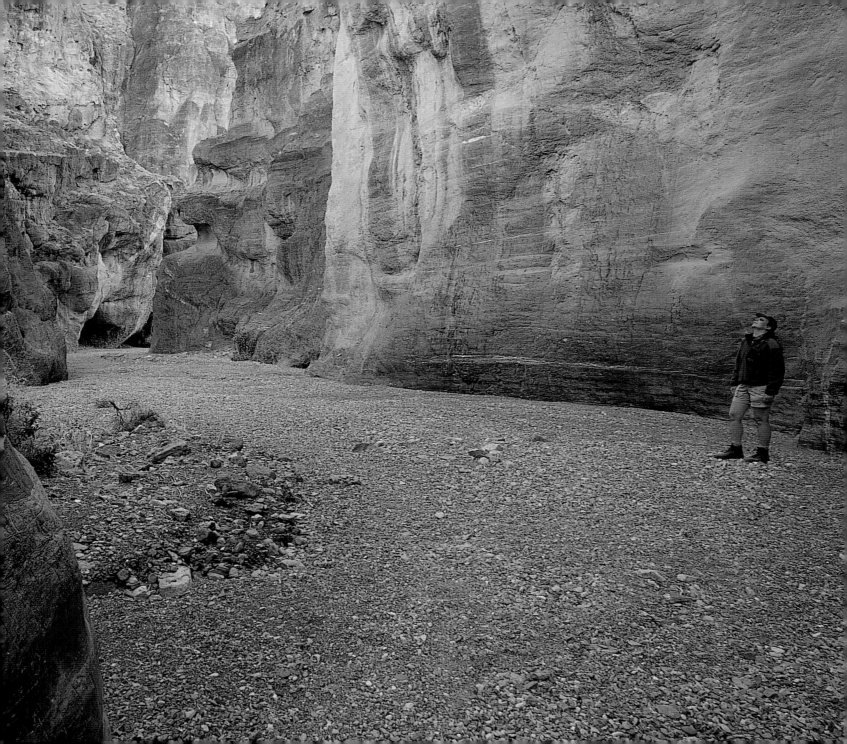

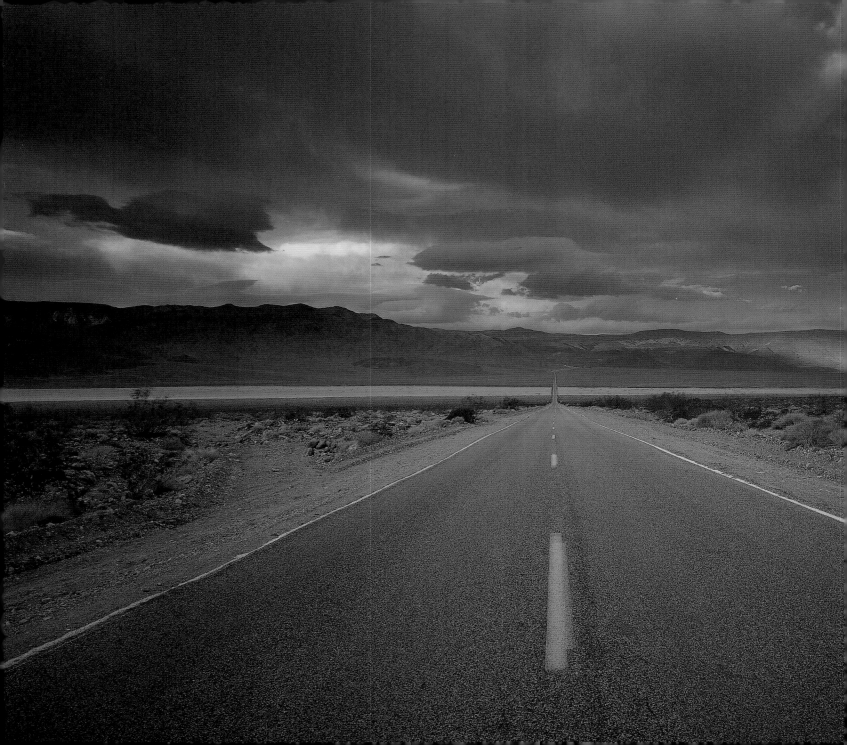

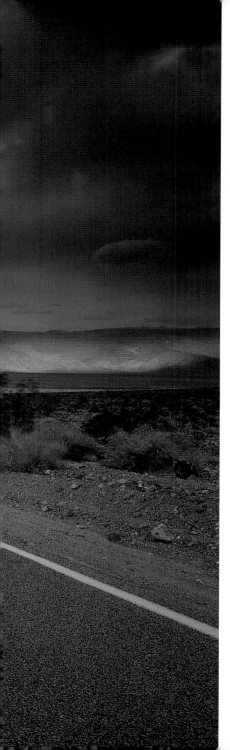

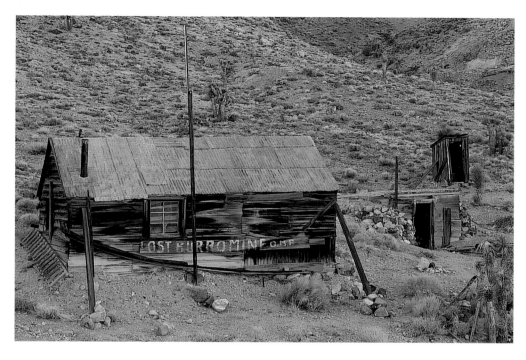

Above: The Lost Burro Mine yielded gold ore from 1907 until the 1970s.
Oben: Die Lost Burro Mine produzierte von 1907 bis in die 1970er Jahre Gold.

Left: California Highway 190 defines straightness as it shoots across Panamint Valley.
Links: Der California Highway 190 definiert den Begriff "gerade" auf dem Weg durch das Panamint Valley.

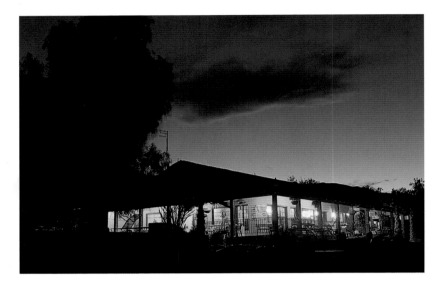

Above: Panamint Springs Resort, Panamint Valley.
Oben: Das Panamint Springs Resort im Panamint Valley.

Right: A trio of hikers view Gower Gulch from atop the badlands near Zabriskie Point.
Rechts: Ein Wanderer-Trio schaut von der Höhe der Badlands nahe Zabriskie Point auf Gower Gulch herab.

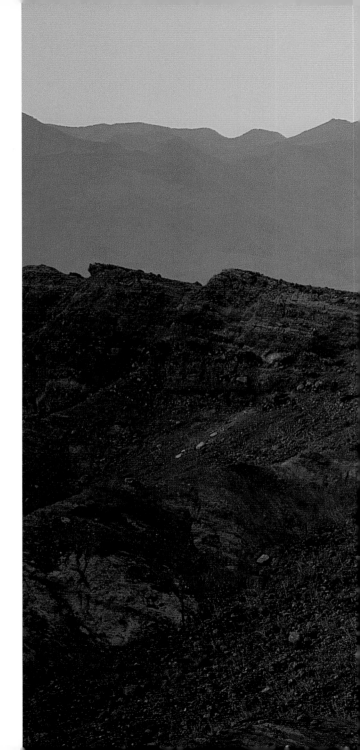

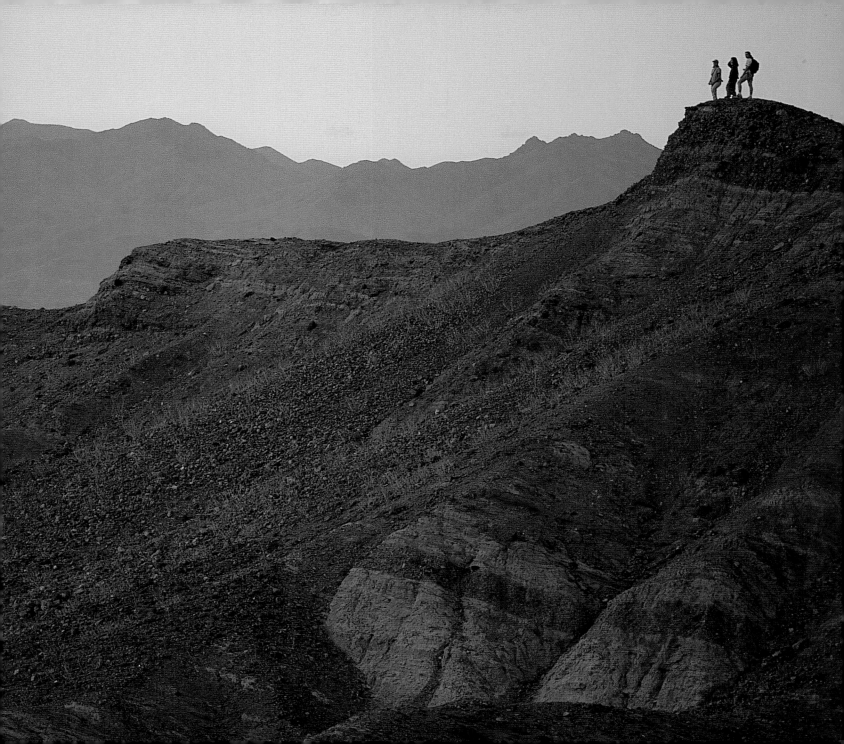

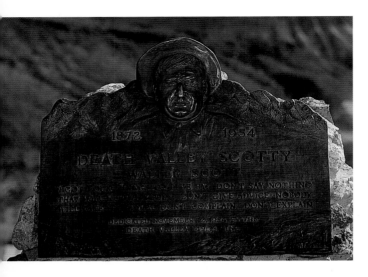

Above: Death Valley Scotty rests above the lavish castle bearing his name.
Oben: Death Valley Scotty ruht oberhalb des verschwenderischen "Schlosses", welches seinen Namen trägt.

Right: Gateway to Scottys Castle, Grapevine Canyon.
Rechts: Der Eingang zu Scottys Castle (Grapevine Canyon).

Facing page: Insurance tycoon Albert Johnson built a castle in Grapevine Canyon after investing in Walter Scott's alleged gold mine. When the mine proved to be a tall tale, Johnson obliged simply because "Death Valley Scotty" made him laugh.
Gegenüber: Versicherungsmagnat Albert Johnson baute ein Schloss, nachdem er in Walter Scotts angebliche Goldmine investiert hatte. Als sich die Mine als Fabel erweis, machte Johnson trotzdem weiter, weil "Death Valley Scotty" ihn zum Lachen brachte.

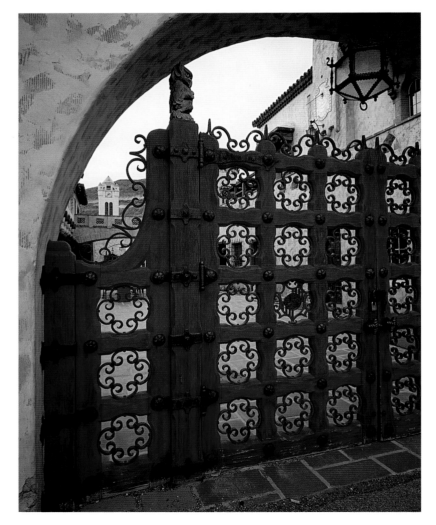

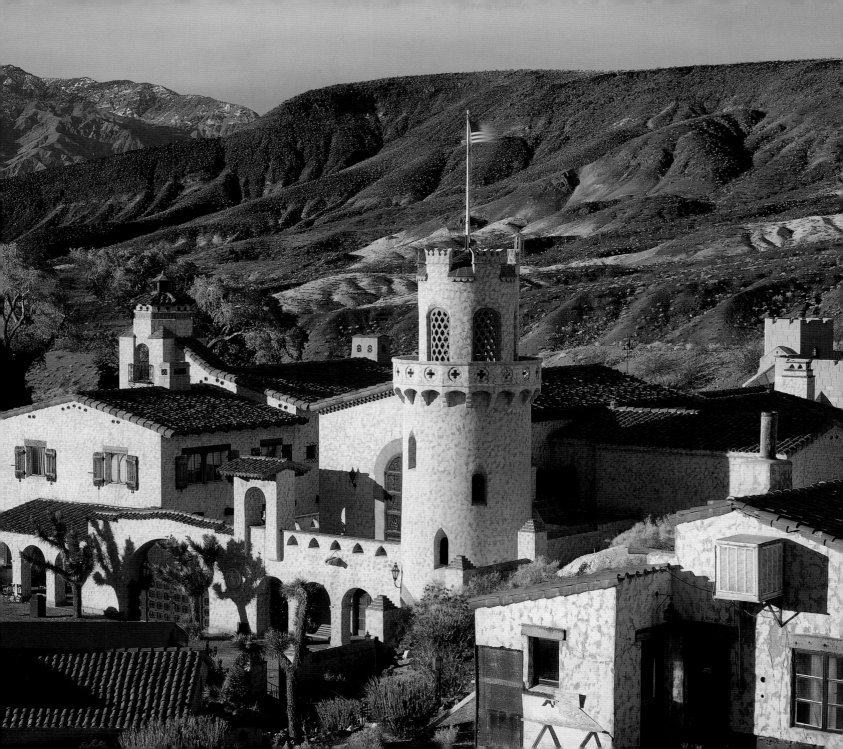

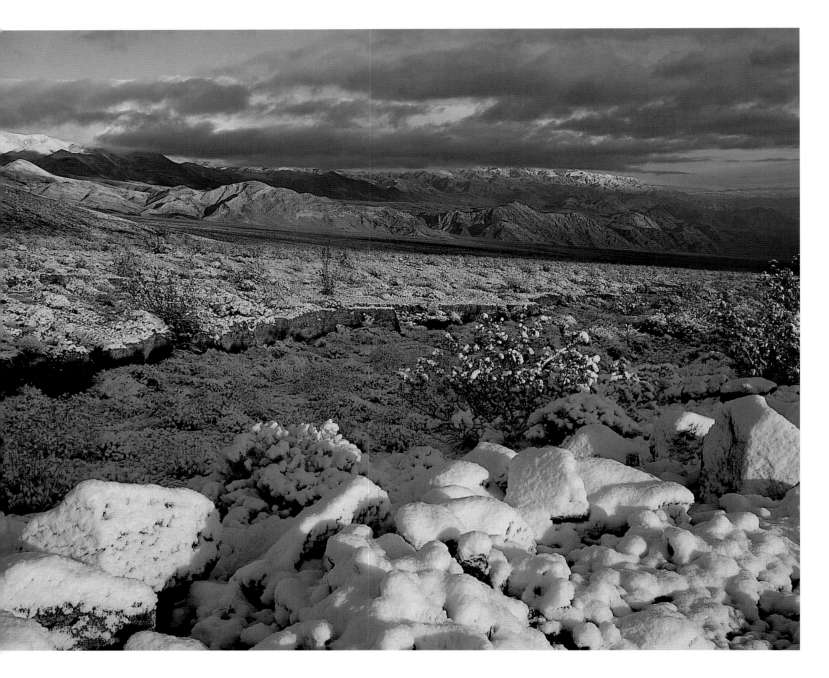

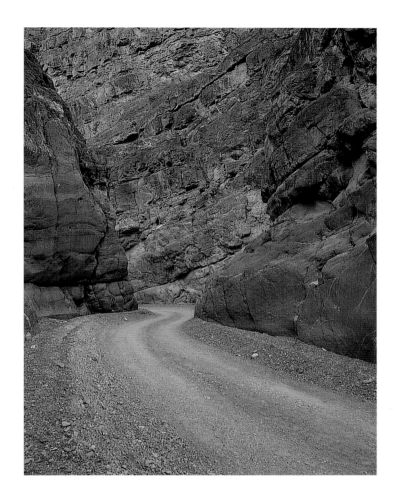

Left: Titus Canyon Road cuts through the Grapevine Mountains.
Links: Die Titus Canyon Road schneidet durch die Grapevine Mountains.

Below: High in the Inyo Mountains, snow shrouds Joshua trees.
Unten: Hoch in den Inyo Mountains bedeckt Schnee die Joshua Tree Kakteen.

Facing page: Snow rarely falls at 3,000 feet in Death Valley, yet this time it stays a few hours, near Towne Pass.
Gegenüber: Selten fällt Schnee in 1.000 Metern Höhe im Death Valley; diesmal jedoch bleibt er für wenige Stunden nahe dem Towne Pass liegen.

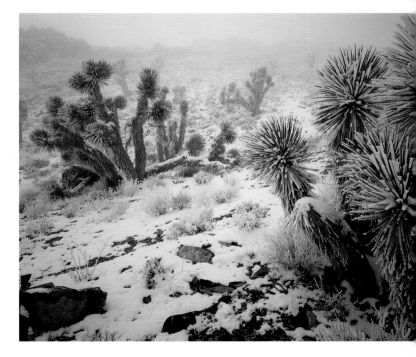

Located over one mile high in the Panamint Range, the gold mines of Skidoo produced California's second-largest yield in 1909.

In über einer Meile Höhe produzierten die Goldminen in Skidoo den zweit-höchsten Ertrag in Kalifornien im Jahre 1909.

Right: The Cook Bank building endures, Rhyolite, Nevada.
Rechts: In Rhyolite, Nevada, hält das Gebäude der Cook Bank weiter stand.

Below: The remnants of Harmony Borax Works, near Furnace Creek.
Unten: Die Reste der Harmony Borax Works nahe Furnace Creek.

Facing page: At the foot of the Nelson Range, the Joshua trees of Lee Flat prepare to take on an approaching storm.
Gegenüber: Am Fuße der Nelson Range stehen die Joshua Tree Kakteen vor einem nahenden Sturm.

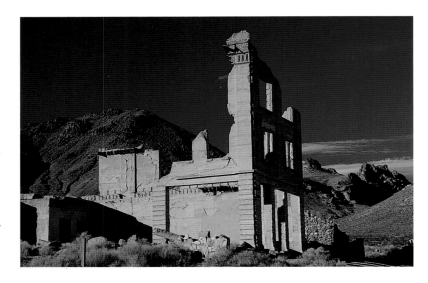

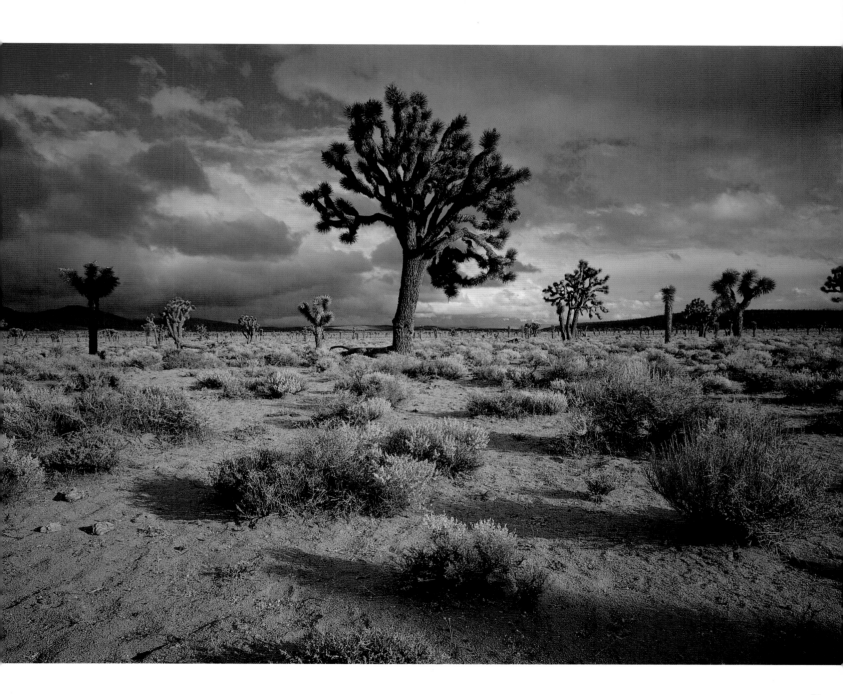

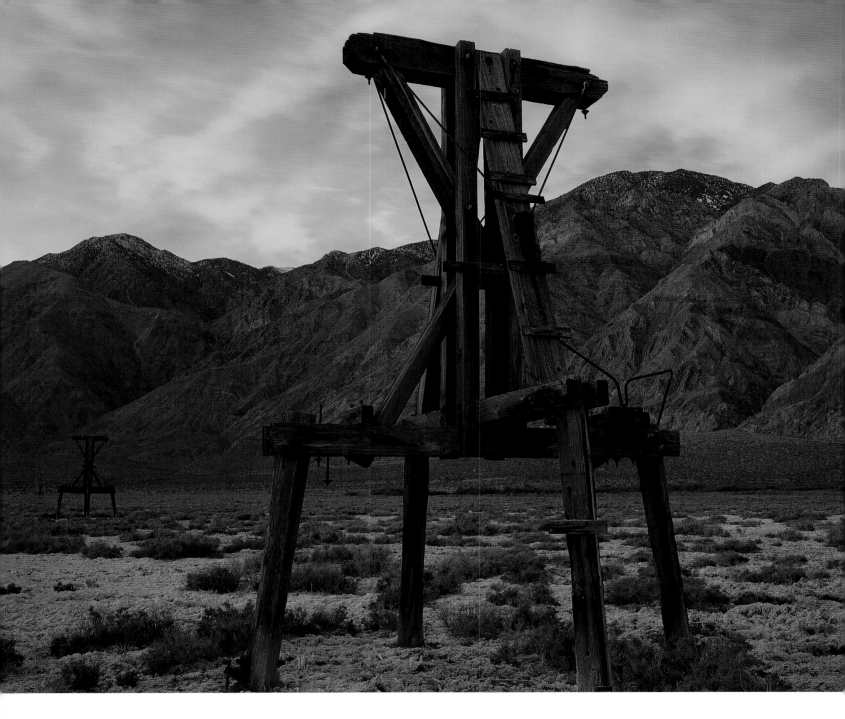

Above: Named in honor of the "Desert Padre," Father Crowley Point overlooks Rainbow Canyon.
Oben: Zu Ehren des "Wüstenpaters" getauft, übersieht Father Crowley Point den Rainbow Canyon.

Facing page: Aerial tram that shipped salt from Saline Valley to Owens Valley via a torturous 13.5-mile route.
Gegenüber: Seilbahn, mit der über eine Strecke von 22 Kilometern Salz vom Saline Valley zum Owens Valley transportiert wurde.

Following pages: Artists Palette is a study of mineral art and shows its colors at twilight.
Folgende Seiten: Artists Palette zeigt seine Farbspiele bei einbrechender Dämmerung.

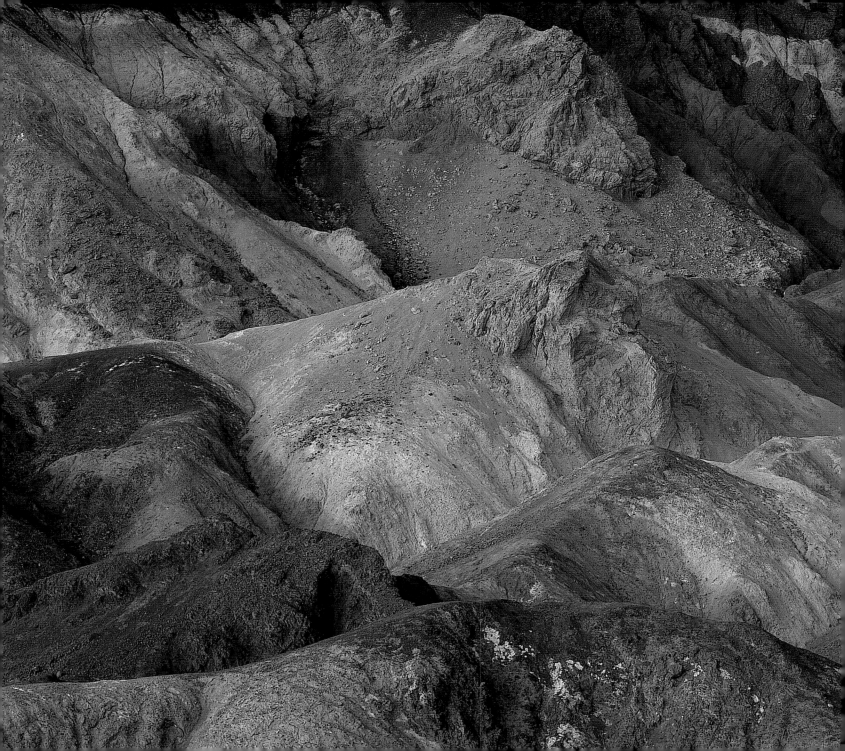

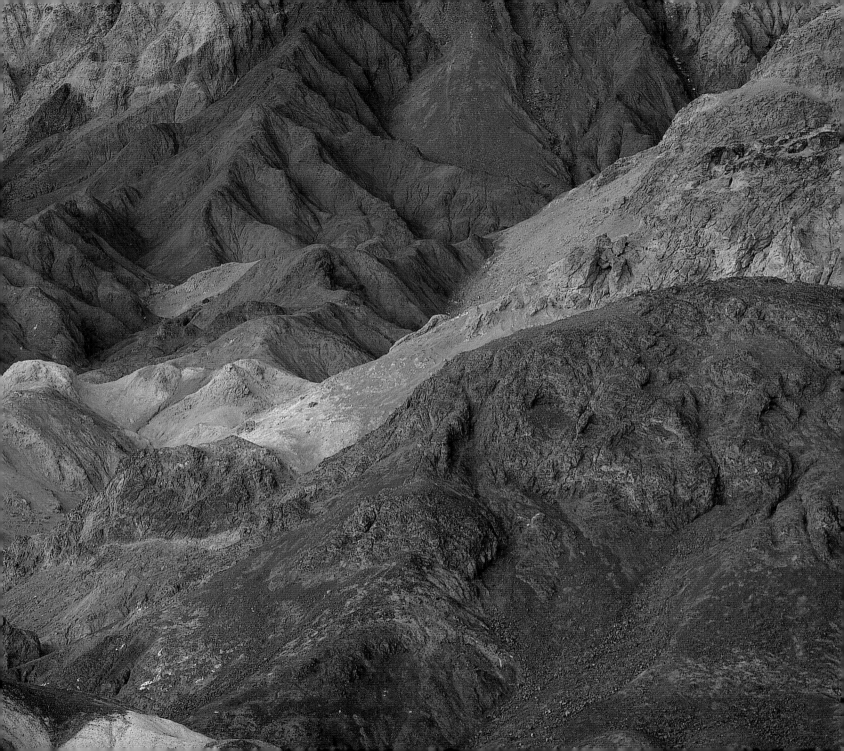

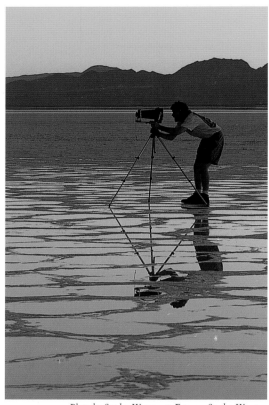

Eric Wunrow's focus is on wilderness photography. His work integrates a library of stock and gallery photographs with a history of creating graphics, identities, words, and illustrations. His award-winning work has been used by NASA, General Motors, Time, Motorola, Coldwater Creek, Coors, National Geographic, and Sierra Club, as well as by clients on five continents. Eric and wife Sandra travel extensively to capture images and ideas. *Death Valley Impressions* is Eric's second book with Farcountry Press, following *Colorado Impressions*, published in 2002. www.EricWunrow.com

Eric Wunrow hat sich auf Wildnisfotografie spezialisiert. Seine Arbeit umfasst sowohl Bilder für Galerien und Archive, das Entwerfen von grafischen Darstellungen als auch Image-Design für Firmen und Illustrationen. Seine preisgekrönten Werke wurden von der NASA, General Motors, Time, Motorola, Coldwater Creek, Coors, National Geographic, dem Sierra Club und anderen Klienten auf fünf Kontinenten genutzt. Eric und seine Frau Sandra reisen extensiv, um Bilder und Ideen zu finden. Death Valley Impressions ist nach Colorado Impressions aus dem Jahre 2002 Erics zweites Buch bei Farcountry Press. www.EricWunrow.com

Photo by Sandra Wunrow • Foto von Sandra Wunrow

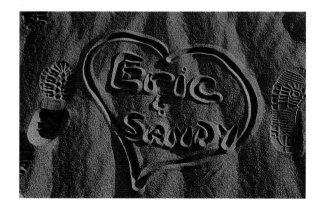

Honeymoon diary, traced in sand, 1988.
Tagebuch der Hochzeitsreise, im den Sand gezeichnet, 1988.